SECRET
BROADSTAIRS

Andy Bull

AMBERLEY

First published 2019

Amberley Publishing
The Hill, Stroud
Gloucestershire, GL5 4EP

www.amberley-books.com

ISBN 978 1 4456 9595 2 (print)
ISBN 978 1 4456 9596 9 (ebook)

British Library Cataloguing in Publication Data.
A catalogue record for this book is available from the
British Library.

Origination by Amberley Publishing.
Printed in Great Britain.

Contents

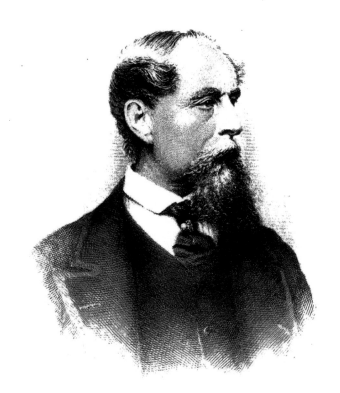

Charles Dickens.

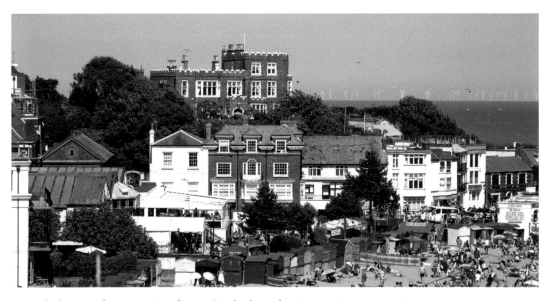

Bleak House dominates Broadstairs. (Acabashi under Creative Commons 2.0)

Preface

Charles Dickens is by far Broadstairs' most famous visitor, and many of his connections with the town are familiar and celebrated, but there are also fascinating secrets to be revealed: about his time here, the people who visited him and, most particularly the relationships he forged with locals.

While it is known that Dickens based the character of Betsy Trotwood in *David Copperfield* on the town's Mary Pearson Strong, her own story – and the enduring legacy she has left to Broadstairs – remains largely unknown.

Bleak House, Dickens's holiday home in Broadstairs, is synonymous with the author. Far less well-known is how Wilkie Collins, Dickens's great friend and collaborator, took over the house after his mentor's death, and why the man who wrote *The Woman in White* in Broadstairs came to think of it as 'the most dreadful place in the world'.

Moving away from Dickens, there is the story of Lord Holland, the eccentric king of Kingsgate, and how he turned a stretch of clifftop into 'another name for paradise', building a mock castle, faux monastery, almshouse and a range of monuments.

The climax of John Buchan's *The Thirty-Nine Steps*, one of the most popular spy novels of all time, famously takes place in Broadstairs, but there is also a little-known – and equally compelling – real-life story of fascists, spies and Nazis to be uncovered at almost exactly the same spot on the North Foreland.

Then there is the allegedly true story of how the Germans attempted to assassinate Lord Northcliffe, proprietor of the *Daily Mail,* at his home in Reading Street. As we shall see, there is a good deal more to that tale than meets the eye.

We will also explore the bar-cum-bookshop that holds the secret behind a visit to the town by Henry VIII's flagship, and reveal the key part Broadstairs played in the downfall of Oscar Wilde.

Finally, there is the overlooked local hero Thomas Crampton: a truly great Victorian pioneer, honoured by the French and Germans, yet never given any official recognition in his home country.

6

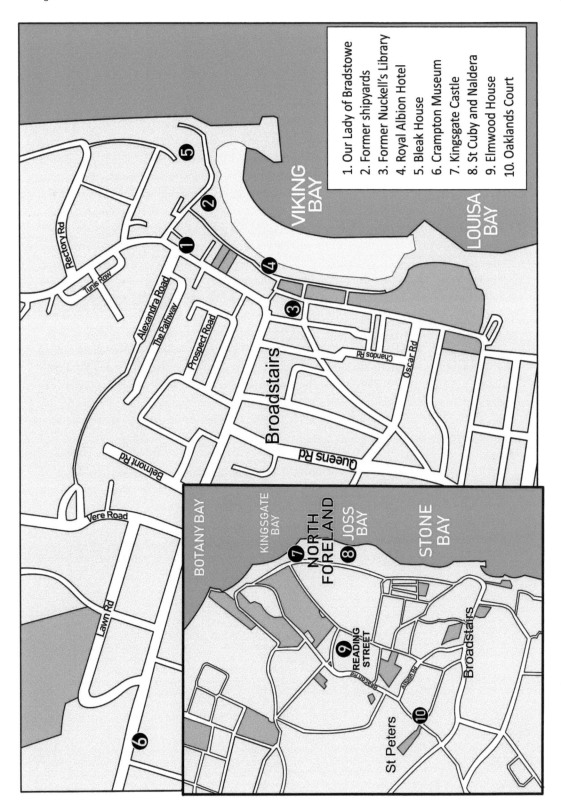

1. Our Lady of Bradstowe
2. Former shipyards
3. Former Nuckell's Library
4. Royal Albion Hotel
5. Bleak House
6. Crampton Museum
7. Kingsgate Castle
8. St Cuby and Naldera
9. Elmwood House
10. Oaklands Court

VIKING BAY

LOUISA BAY

Rectory Rd

Tuns Row

Alexandra Road

The Pathway

Prospect Road

Broadstairs

Chandos Rd

Oscar Rd

Queens Rd

Belmont Rd

Vere Road

Lawn Rd

BOTANY BAY

KINGSGATE BAY

NORTH FORELAND

JOSS BAY

STONE BAY

READING STREET

Broadstairs

St Peters

1. Broadstairs and the Sea

Our Lady of Bradstowe, Star of the Sea

The year is 1514, and a great ship is anchored off the tiny Thanet fishing village of Bradstowe, in what is now called Viking Bay. It makes an incongruous sight. To all appearances Bradstowe is an insignificant little place: a mere clutch of cottages gathered on the chalk cliffs above a bay that, lacking anything but the most rudimentary protection against storms, could not really be called a harbour.

The ship, however, is the finest in the land. The *Henry Grace á Dieu* is Henry VIII's newly launched flagship. Contemporary with the *Mary Rose* but even larger, this is a floating castle: 58 metres long, bristling with 184 cannon, a forecastle four storeys high and with a crew of 700 men. Known as the *Great Harry*, she is luxuriously fitted out as a royal showpiece. Flags fly from the top of every mast, alongside elaborately embroidered pennants.

Yet, however effective the *Great Harry* might be as a warship, its mariners would not think of putting to sea in her before she had been blessed at the shrine of Our Lady of Bradstowe, Star of the Sea.

Henry Grace à *Dieu*. (Gerry Bye, Anthony Roll under Creative Commons 2.0)

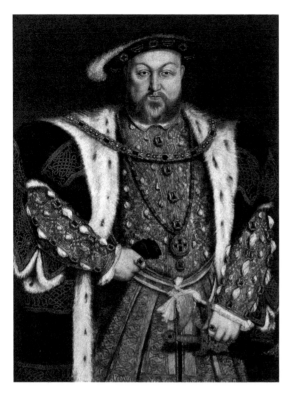

Henry VIII. (The Wellcome Collection)

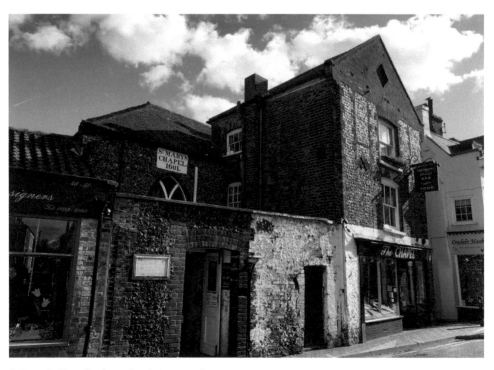

St Mary's Chapel, where the shrine stood.

So here the ship has come, its crew filing up a rough track leading inland from the chalk shore to a wooden statue of the Virgin Mary, which has been here, and been venerated by mariners, since at least the eleventh century.

Modern Broadstairs overlays most of the route they took. The shrine has long disappeared, and the chapel that then stood alongside it has since been destroyed and rebuilt at least twice, but there is still some evidence of the original building on the ground. To get a sense of this once vitally significant place, stand in Albion Street, with No. 44, The Chapel bookshop and bar to your left, and look down the alley before you. This is Chapel Stairs.

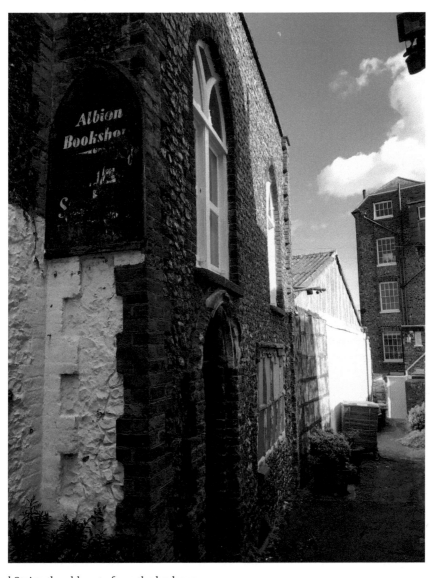

Chapel Stairs, the old route from the harbour.

Today the route is blocked by a house in Eldon Place after 30 yards or so, but in 1514 a set of simple steps cut into the chalk cliff led up here from the shore, a path since lost beneath what is now Broadstairs Sailing Club and The Pavilion. A plaque on the wall fills in a little of why those mariners came here 500 years ago.

In those times, Our Lady of Bradstowe, Star of the Sea, was a hugely venerated place. The shrine was a hollow, painted wooden statue of the Virgin Mary with what were claimed to be holy relics inside. There was also a cliff top cross and a stone chapel with twin towers. From one of the towers, a blue light shone, visible to passing ships, and a renowned navigational aid to craft that, heading east, must round the notorious North Foreland or, headed west, navigate the treacherous Goodwin Sands.

Following the visit of the *Great Harry*, which, after a Mass, culminated in a great feast put on by villagers for the crew, ships that passed the shrine would lower the flag on their main mast, or fold their topsail, in thanksgiving to Mary for a safe voyage – the origin of the tradition of 'showing the flag' still observed today by the Royal Navy when calling at seaside towns.

It was also said that Mary's statue had the power to warn of impending storms. When dangerous weather threatened, the statue would appear to weep. It may be that, when the air became saturated with moisture, drops would form on the smooth painted surface and run down Mary's face.

Whatever the reason, this phenomenon was attributed with such power that monarchs, pilgrims, fishermen and sailors all came to pay their respects. As Jonathan Davies says in *The King's Ships*, 'The medieval church was a powerful and omnipresent influence.' The names of ships (*Henry Grace à Dieu* means Henry by the Grace of God), 'the codes of discipline based on Biblical passages, the compass rose marked with a cross to show the way to Jerusalem, demonstrated how Christianity pervaded everything, even the guns declared on their barrels that Henry was the "Invincible, Defender of the Faith".'

However, six years after the *Great Harry's* visit in 1520, a cataclysmic event that Our Lady of Bradstowe was powerless to guard against devastated the village. A violent storm, which raged for several days, culminated in a great surge tide that overwhelmed Bradstowe, smashed the chapel to pieces and destroyed the shrine.

DID YOU KNOW?
In 1588, as the Spanish Armada fought its way up the English Channel, Broadstairs played a vital role in victualling the English fleet. Despite the town's best efforts, there were so many wounded sailors that they could not cope, and many were dying of their injuries. Sir Henry Seymour, Commander of the Squadron of the Narrow Sea, sent a message to Queen Elizabeth that his ships, anchored a mile off St Bartholomew's Gate [now Kingsgate] were in mortal peril, writing: 'Many seamen with ye sickness are at Meergate [Margate] and Bradstowe [Broadstairs] ... I request medicine most urgent.'

York Arch and the shipyards' site.

At this point a family of shipwrights, the Culmers, enter the story. George Culmer did much to make amends. He rebuilt the chapel and, it is believed, replaced the shrine. He also laid the foundations of modern Broadstairs, cutting a new set of wide steps – or broad stairs – at a point just to the east of Chapel Place, passing his shipyard and leading down to the shore, where, in 1538, he built a pier, creating a proper harbour. In 1540 he built Flint Gate, an arch supporting stout wooden doors, across what is now called Harbour Street to protect the town from attack by privateers. It was renamed York Gate after the Duke of York when restored by Lord Helliker in 1795.

With Henry VIII's break with Rome came a drastically revised view on the veneration of shrines such as that of Our Lady of Bradstowe. The chapel was suppressed, the building smashed, the statue of Our Lady and prominent cross were removed, and the guiding blue light snuffed out for good.

The building then, according to Historic England, became the private property of another Culmer, Sir John, a Puritan and early pioneer of the Congregationalist movement – a breakaway from the newly formed Church of England – in which the congregations of individual churches saw themselves as independent of any hierarchy. In 1601 Sir John radically rebuilt the chapel and, by some accounts, established a new shrine in a side chapel. This would have been a highly unusual thing for a Congregationalist to do, as they tended to reject concepts such as the veneration of saints, but not impossible.

He incorporated much material salvaged from the earlier chapel. The first pastor was a third Culmer, Joel. From then, what became known as St Mary's – or sometimes Culmer's Chapel – has had a chequered history. Historic England records worship being led in 1691 by Josia Culmer, with services held in association with the Presbyterian or Congregational meeting in Ramsgate. In 1714 an adjoining building, probably No. 1 Chapel Place, to the east was converted into 'two cottages for visiting clergy', but this was demolished in 1930.

Catholic Our Lady Star of the Sea. (Le Deluge under Creative Commons 2.0)

Holy Trinity C of E, home to a modern shrine.

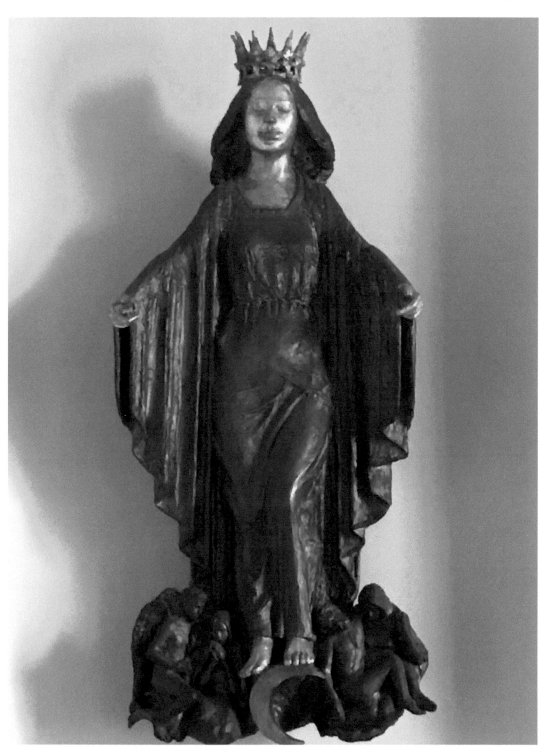

Our Lady of Bradstowe by John Doubleday, in Holy Trinity.

In 1825–28 the chapel was again largely rebuilt, incorporating an early seventeenth-century five-light stone mullioned and transomed window, a window arch and a resited medieval door arch. It is this version of the building that is largely extant today. The work, paid for by Mary Goodwin, a prominent nineteenth-century Broadstairs Christian philanthropist and member of the congregation, involved raising the roof and adding a wooden gallery, costing £1,000. In the 1830s it was a Baptist place of worship, and tablets later found in the building show that 'middle-class Nonconformists' including Mrs Goodwin and members of the Culmer family 'were being buried in a vault beneath the chapel at this time'.

In 1871 the Congregationalists built themselves a new chapel in The Vale, and from then the front portion of the building appears to have been used as a shop, including as a smithy and a greengrocer.

In 1924 the chapel was used by another nonconformist sect, the Plymouth Brethren, before becoming the parish room for the C of E Holy Trinity Church in 1926. From the 1950s it became the Albion Bookshop, and now continues that role as well as being a craft beer pub.

The shrine to Our Lady of Bradstowe does, however, live on in two guises. Firstly, it gives its name to the Roman Catholic Church of Our Lady Star of the Sea, designed in 1929 by Sir Giles Gilbert Scott, but not completed until 1963, at No. 17 Broadstairs Road, St Peter's. Secondly, there is a modern shrine to Our Lady of Bradstowe, Star of the Sea, in Holy Trinity, Nelson Place. In 1925, when this Victorian church was being extended, a Lady Chapel was created in the south aisle. In 1980 a new statue of Our Lady of Bradstowe was commissioned and placed there in a niche on the east wall.

The shrine's original medieval Latin title, *Stella Maris*, continues today in Broadstairs' civic crest.

Shipbuilding and Lifeboats

From the fifteenth century shipbuilding was the most important industry here. Alongside the Culmers, the Whites were the other great Broadstairs shipbuilding family. The White shipyard stood where the Pavilion, built in 1933, is now, to the west of Harbour Street. The Culmer yard was below it, where the Garden on the Sands is today.

Two intermarriages forged links between the Culmer and White families and led to their yards being combining under the White name. In 1714, John White married Mary Culmer and, in 1720, they built a home, Flint House, now replaced by the late Georgian building at No. 21 Harbour Street, right by their combined yards. In 1754 Susanna, a daughter of Sarah Culmer, married another John White.

Michael Flint, in *In Search of the Broadstairs Shipbuilding Industry,* recounts how ships for the West Indies route and fast cutters for the Revenue were built at White's yard in the eighteenth and early nineteenth centuries. There were also ships for the Royal Navy including, in 1764, a ten-gun cutter called HMS *Lapwing*. The last Royal Navy ship built at Broadstairs was HMS *Desperate*, a coastal patrol vessel, in 1804–05. The yard remained busy. In 1807 Lloyd's register lists fifteen ships built at Broadstairs, but the White's flourishing business was outgrowing the town.

Broadstairs Pier. No. 3.

Broadstairs harbour in the nineteenth century.

A combination of a shortage of local oak, insufficient skilled labour, the compact nature of Broadstairs harbour and a need to be close to a key customer, the Royal Navy at Portsmouth, led John White & Co. to move to Cowes on the Isle of Wight.

By some accounts, the move occurred in the first decade of the nineteenth century, but evidence that the Whites were still building some ships at Broadstairs up to 1824 suggests they operated at both locations for a number of years, with Thomas White running Cowes and his brother Culmer White – his name reflecting the union between the two families – running Broadstairs. By the 1850s the yard was gone, the 1851 census showing that York Gate House and the former yard were now occupied by a school run by Miss Rose Miles.

The Whites and the *Northern Belle*

One specialism of White's Cowes yard was the provision of lifeboats, and in 1850 they provided the first of two for Broadstairs. It was unnamed when delivered, but the following year was christened after a ship driven onto the Goodwin Sands in a gale, whose crew it rescued. That ship, coincidentally, was the *Mary White*. The second boat, delivered later that year, was named the *Culmer White*.

Both boats took part in one of the most famous sea rescues. On 5 January 1857 the American *Northern Belle*, bringing wheat, flour and linseed cake from New Orleans to Liverpool and Le Havre, was forced by a heavy gale to take shelter in Kingsgate Bay, anchoring three quarters of a mile offshore. However, the storm was so ferocious, with waves breaking right over the ship, that at 6.30 in the morning the crew of twenty-three

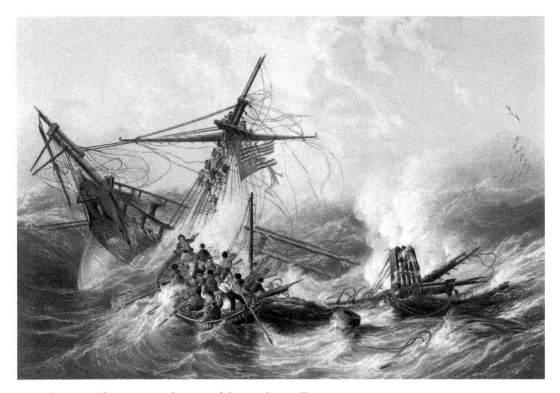

The *Mary White*, rescuing the crew of the *Northern Belle*.

had to cut away the main and mizzen masts. All day the storm raged, preventing the launch of the Broadstairs lifeboats and others along the coast.

Three ships attempted rescues unsuccessfully, with the Margate lugger *Victory* lost with all her crew. By midnight things were desperate: the storm had torn the *Northern Belle* from her anchorage and she was in danger of being driven onto the rocks.

The decision was made to haul the *Mary White* and the *Culmer White* 2 miles overland through snow to Kingsgate Bay, where they could be launched. All hands were rescued in three perilous missions. In gratitude, the US President Franklin Pierce issued silver medals for the twenty-one lifeboat men, and a reward per man that would equate to around £1,000 today.

There are present-day reminders of the Culmer name in Broadstairs. Culmer's land, an area of allotments and utility land at the end of Alexandra Road, was bequeathed to the town by Richard Culmer in 1434.

Icelandic Cod Fishing

Hasted, in his *History of the County of Kent*, says that in 1565 there were ninety Broadstairs families 'chiefly employed in the Icelandic cod fishery, and that trade seems to have been sustained through to the eighteenth century. John Mockett, in *Mockett's Journal* for 1786, writes that 'Broadstairs is a small fishing place ... the inhabitants are few, they have vessels trading to Iceland, to the cod fishery, and to enable them to perform their voyage many

farmers, and their sons, are induced to advance a sum, which they call a venture, say ten, fifteen, or twenty pounds in shares, towards freighting those vessels and partake of the profits if any on their return.'

This suggests that many locals not directly involved in fishing were funding the expeditions and sharing in the profits.

Bob Simmonds in *Broadstairs Harbour* points out that, as most of the Icelandic fleet was based in Yarmouth and Kings Lynn, it may be that the boats were not based here, or owned by Broadstairs fishermen, but that the men travelled to East Anglia to work on ships sailing from there. Ships set sail in March, in convoys to protect them from privateers, and returned in August or early September.

The fish would be salted at sea and sold at East Anglian auctions to merchants who distributed them nationally. Hasted adds that Broadstairs families also 'make a considerable trade from the oil drawn from the livers of the fish, which are brought home hither in casks for that purpose'.

Smugglers

Smuggling was not just a lucrative sideline in Broadstairs; for many it was a way of life and underpinned the local economy from 1700 to 1840. In 1723, Daniel Defoe reported:

Bradstow is a small fishing hamlet of some 300 souls, of which twenty-seven follow the occupation of fishing, the rest would seem to have no visible means of support. I am told

Kingsgate Bay, once a notorious smugglers' haunt.

A tunnel cut into the cliff by smugglers.

that the area is a hot bed of smuggling. When I asked if this was so, the locals did give me the notion that if I persisted in this line of enquiry some serious injury might befall my person.

William H. Lapthorne, in *Smugglers' Broadstairs,* argues that the roots of smuggling around Broadstairs are wrapped up in its association with the Cinque Ports. Inhabitants of the confederated ports of Hastings, Hythe, Rye, Sandwich and Dover were exempt from tolls and authorised to export and import without paying taxes or dues. In return, they had to provide ships and men for the defence of the realm. Bradstowe – as a part of St Peter's, the then principal settlement – was associated with the Cinque Ports as a 'limb' of Dover, and shared in those privileges and obligations.

Lapthorne says: 'So the Bradstonians claimed that smuggling was their right for being part of a Cinque Port.'

Even the local geography favoured smuggling. To the east of Broadstairs are Stone Bay, Joss Bay, Kingsgate Bay and Botany Bay. Each was then remote and unpopulated, with a gently sloping sandy beach backed by chalk cliffs in which caves and tunnels could easily be cut. In addition, local farmers had dug 'gates' – tracks down through the cliffs – so that carts could be bought down and loaded with seaweed to be spread on the fields as fertiliser. Such cart tracks were also ideal for moving contraband from the beaches.

To evade the revenue men, who at night often hid on the cliffs watching these gates, contraband would he hidden in caves. Next morning, farmers would come down to the beaches, ostensibly to gather seaweed, and hide the smuggled goods beneath their loads.

Smuggling was as corrosive as the trade in illegal drugs can be on a modern community. Poorly paid farmworkers could make more in one night than they could in a month on the land, so many gave up farm work. Farmers were so desperate for workers that they doubled, then trebled wages but still could not find men. As a result, crops could not be harvested and, in 1735, flour was so scarce that London was hit by a severe bread shortage.

Penalties for smuggling were raised, ranging from transportation for life to hanging. Consequently, smugglers were even more determined not to be apprehended. Botany Bay gained its name because so many of those caught were transported to the penal colony of Botany Bay in Australia.

Smuggling gangs were superior in numbers and fire power to the revenue men. Lapthorne writes that, on 7 April 1746, the Collector of Customs reported: 'a large gang of smugglers with several led horses went thro' this town [Broadstairs] into the isle of Thanet, and there is a gang of 200 at St Peter's, they are so well armed, and we are in such miserable numbers that we are unable to molest them, and beg leave of assistance from the military.'

The Fig Tree Inn, now Fig Tree Cottage, on the corner of Callis Court Road and Fig Tree Road was a notorious smugglers' haunt in the eighteenth century. In 1783, smuggling was so bad in the area that the 13th Light Dragoons were sent in to help the revenue men stamp it out and billeted at the inn. They were so ineffective – perhaps because soldiers were poorly paid and easily bribed – that after four months, smuggling had actually increased by a half.

The Fig Tree Inn was closed down, and the doorway blocked up, but the stone frame can still be seen at the cottage. Opposite the Fig Tree is Lanthorne Road, which leads to

Blocked doorway at the former Fig Tree Inn.

Farm Cottage, once home to Joss Snelling.

the coast. Halfway down it is Farm Cottage which, in the eighteenth century, was Callis Court Cottage, home to Broadstairs' most notorious smuggler, Joss Snelling, leader of the Callis Court Gang. By some accounts Joss gave his name to Joss Bay, but it is more likely that he is named after it.

Joss Snelling's most infamous exploit – the Battle of Botany Bay – took place in March 1769 when the *Lark,* an armed lugger, dropped anchor off Kingsgate Bay. It carried a cargo including brandy, schnapps, tea and lace – all highly taxed items. For once, the revenue men lay in wait. In the ensuing battle, six smugglers were killed. Joss Snelling and three others escaped. Reaching the top of the cliffs they were challenged by a lone revenue man, who was shot and left for dead.

DID YOU KNOW?
There are several alternative stories behind the figureheads on the harbour boathouse. The Scotsman figure bears a sign declaring it to have been recovered from the *Highland Chief,* wrecked on the Goodwin Sands in 1869. Another account is that the figure came from the *Inverary,* lost on the Goodwins in 1871, a third version is that it is from the *Clan Cluny.*

The figurehead of Hercules, generally believed to have been salvaged from a Spanish brig of that name in 1844, could, alternatively, represent Jason and the Golden Fleece, or possibly Samson, wearing the mane of a lion that he has killed.

The Scotsman figurehead.

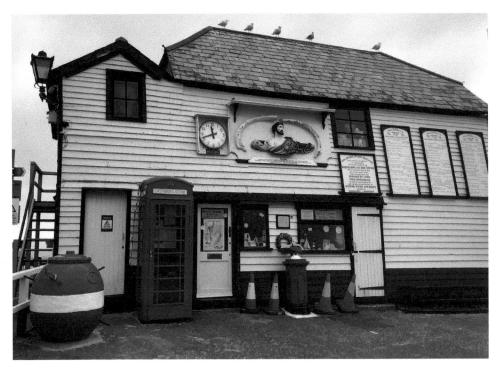

The figurehead of Hercules on the boathouse.

During a house-by-house search, two smugglers – one dead, the other dying – were discovered in Rosemary Cottage in the hamlet of Reading Street. (Rosemary Cottage was again the scene of violent death – of a very different kind – in the twentieth century, as we shall see in chapter four.)

Nine members of the Callis Court Gang were later tried at Sandwich and hanged in Gallows Field. Joss Snelling was never caught and, within a year, controlled a gang of twice the size, despite having lost most of his men that night in Botany Bay. Although Snelling was well known as a smuggler, he never received serious punishment. Even aged eighty-nine he was active, receiving a £100 fine. Born in 1741, he lived to be ninety-six. In 1829 he was presented to the young Princess Victoria as 'the famous Broadstairs smuggler'.

White's shipyard profited from both sides in the war against smuggling, according to Lapthorne: 'in the eighteenth century they were building cutters for the Revenue service, which were designed for speed … Unfortunately for the customs the wily Thanet smugglers were also good customers of White's, and often on the slips of the shipyard that stood where the Garden on the Sands is today could be seen a revenue cutter and a smuggling cutter being built side by side.'

Smugglers' haunts in Broadstairs included several premises in Union Square. Where the Old Curiosity Shop now stands in Harbour Street were two cottages, beneath which was a well. Contraband was sealed in jars or barrels and dropped into the well. During renovation work, the remains of four late eighteenth-century brass-rimmed sprits kegs were discovered. There was also a pub called the Five Tuns in Union Square where, in

1807, a search for contraband appeared to have proved fruitless. However, as two revenue men were drinking outside, one sat on a dog kennel, which promptly collapsed. The false roof held 80 lbs of tobacco.

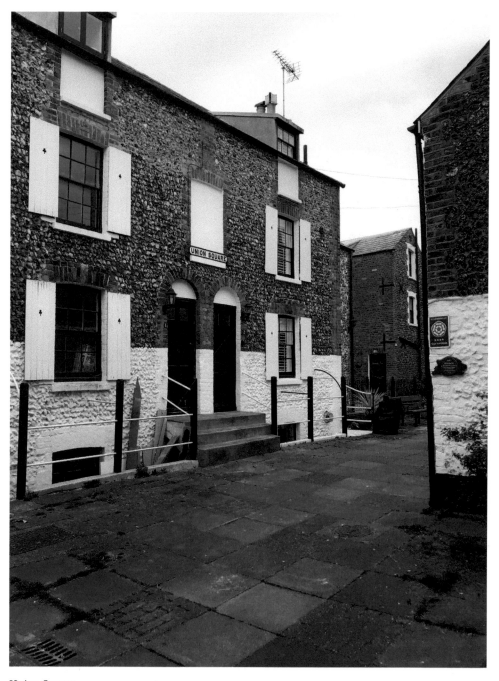

Union Square.

2. Charles Dickens and a Living Legacy

Charles Dickens is by far Broadstairs' most famous visitor. Many of his connections with the town are well known and celebrated, but there are secrets to be uncovered: about his time here; the people who visited him; and, most particularly, the relationships he forged with locals.

Mary Pearson Strong, the Model for Betsy Trotwood in David Copperfield

Dickens based the character of Betsy Trotwood in *David Copperfield* on a formidable spinster called Mary Pearson Strong, who lived in a cottage at No. 2 Victoria Parade alongside Broadstairs' harbour.

That much is very well known. Miss Strong's former home is now named Dickens House and hosts a museum in the author's memory, full of items associated with him.

Little is known, however, about who Mary Pearson Strong was. Her untold story turns out to be a fascinating one, and her name lives on in Broadstairs through charities that she, her sister and brother-in-law established.

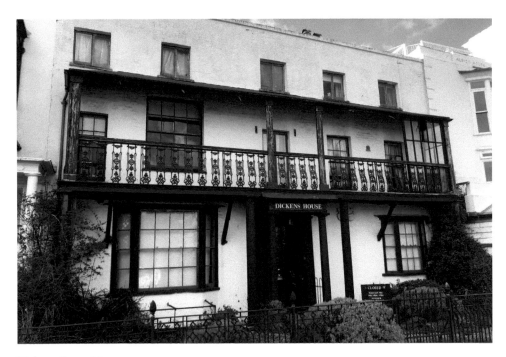

Dickens House Museum.

Betsy Trotwood deals with donkeys. (Philip V. Allingham, Victorian Web)

Nuckell's Place gardens, once fiercely protected by Mary Pearson Strong.

First, let us run through what is generally known about Miss Strong and her friendship with Dickens. The author became aware of her as he looked out from the Royal Albion Hotel, where he first stayed in 1839. He was much amused by her repeated conflicts with the boys who allowed their donkeys to graze on the grass verge in front of her cottage.

In *David Copperfield* Dickens wrote:

To this hour I don't know whether my aunt had any lawful right of way over that patch of green; but she had settled it in her own mind that she had, and it was all the same to her. The one great outrage of her life, demanding to be constantly avenged, was the passage of a donkey over that immaculate spot ... Jugs of water, and watering-pots, were kept in secret places ready to be discharged on the offending boys; sticks were laid in ambush behind the door; sallies were made at all hours; and incessant war prevailed. Perhaps this was an agreeable excitement to the donkey-boys; or perhaps the more sagacious of the donkeys, understanding how the case stood, delighted with constitutional obstinacy in coming that way.

Dickens, who loved a practical joke, would sometimes give the donkey man a shilling to provoke a confrontation. He moved Aunt Betsy's cottage to Dover in the novel, and placed it on the clifftop, but the parlour described in *David Copperfield* is easily recognisable when you visit today.

His son Charley wrote in the *Pall Mall Gazette* in 1896: 'Miss Strong – a charming old lady who was always most kind to me as a small boy, and to whose cakes and tea I still look back with fond and unsatisfied regret – [was] firmly convinced of her right to stop the passage of donkeys along the road in front of her door.'

David Copperfield was a highly autobiographic novel, the title character closely based on Dickens himself, which makes it significant that the author chose Miss Strong as the model for Aunt Betsy, a person very close to his hero. Dickens got to know Miss Strong well during his repeated visits to Broadstairs, which continued virtually each year, often from May until October, until 1851.

We don't know how close Dickens was to Miss Strong, but there may be some echo of their relationship in the strong bonds his fictional alter ego has with Miss Trotwood. Aunt Betsy takes David in when he runs away from his stepfather's factory in Blackheath, where, following his mother's death, he had been set to work labelling wine bottles. She finds him a place at a good school in Canterbury. Significantly, Dickens names the head of that school. Dr Strong, after her.

Here is what is far less well known about Mary Pearson Strong, a member of the wealthy brewing family from Hampshire. She had a sister, Ann, and while Mary remained single – like her fictional counterpart –Ann married Stephen Nuckell in 1799. Stephen owned the cottage that became Miss Strong's, and several adjoining buildings in what was then called Nuckell's Place, plus the land running down to the cliff edge, now an enclosed garden.

Ann was Stephen's second wife. He was a prominent figure in Broadstairs, running Nuckell's Library and the town's Assembly Rooms, later renamed the Royal Kent Marine Library, which stood at the western end of Nuckell's Place (now Victoria Parade) where the Charles Dickens Inn is today. Mary, Ann and Stephen share a tomb in St Peter's churchyard.

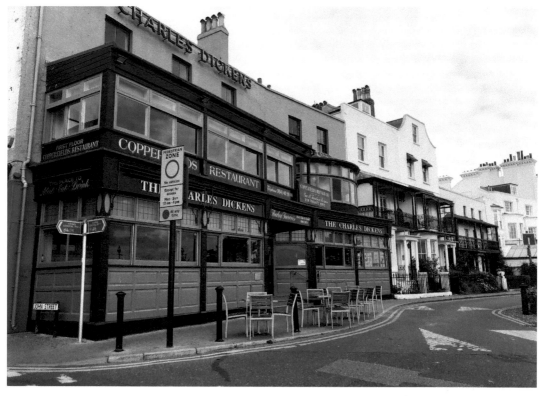

The Charles Dickens inn, formerly Nuckell's Library, and Stephen's other properties.

In *Our English Watering Place,* Dickens's affectionate portrait of Broadstairs, he pokes gentle fun at Nuckell's Library. By the time of his first holiday in Broadstairs in 1837, Stephen Nuckell had been dead for three years, and the once-distinguished place was in decline.

There is still an Assembly Rooms, a bleak chamber rumoured once to have held concerts and balls, but that is in the dim and distant past. It has a discoloured old billiard table. Sometimes, a misguided wanderer of a Ventriloquist, or an Infant Phenomenon, or a juggler, or somebody with an Orrery [a clockwork model of the solar system] that is several stars behind the time, takes the place for a night, and issues bills with the name of his last town lined out, and the name of ours ignominiously written in, but you may be sure this never happens twice to the same unfortunate person ...

Attached to our Assembly Rooms is a library. There is a wheel of fortune in it, but it is rusty and dusty, and never turns. A large doll, with moveable eyes, was put up to be raffled for, by five-and-twenty members at two shillings, seven years ago this autumn, and the list is not full yet.

From *Our English Watering Place* it is clear Dickens spent a good deal of time in Nuckell's Library, and took delight in leafing through the books he found there, intrigued to learn

about those who had read them before him. In an example of how closely Dickens's real life was interwoven with his fiction, he writes:

> The leaves of the romances, reduced to a condition very like curl-paper, are thickly studded with notes in pencil: sometimes complimentary, sometimes jocose. Some of these commentators ... quarrel with one another. One young gentleman who sarcastically writes 'O!!!' after every sentimental passage, is pursued through his literary career by another, who writes 'Insulting Beast!' Miss Julia Mills has read the whole collection of these books. [Julia Mills is Dora Spenlow's intensely romantic young friend and confidante in *David Copperfield*] She has left marginal notes on the pages, as 'is not this truly touching? J. M.' 'How thrilling! J. M'.

Broadstairs inhabitants took no offence at Dicken's portrayal of it, and them. After he had stopped coming regularly, *The Illustrated Times* reported: 'They evidently cherish [Dickens's] memory at the library, and date the events in their lives from the happy time when the great novelist dwelt among them.'

Stephen Nuckell's death, in 1834, coincided with a change in the law regarding provision for the poor. The story of how the workhouse in the High Street came to be renamed in his honour, as Nuckell's Almshouse is a fascinating one. John Wood, clerk to the trustees of Nuckell's Almshouse, says that the building

> was believed to have been built in 1805 by Thomas Brown as the poor house or workhouse of the village. By the 1834 Poor Law Amendment Act, St. Peter's was incorporated into the Union, which had its workhouse in nearby Minster-in-Thanet and, although there was a petition, some two years later St. Peter's poor were removed to the Union at Minster.
>
> 'Brown's workhouse was subsequently put up for sale and Ann Nuckell purchased it for £700, the conveyance being made through the vicar, John Hodgson. She then advanced £100 to convert it into separate almshouses for ten widows. The date of 1838 seen on the building is the date it became an almshouse.

Nuckell's Almshouse.

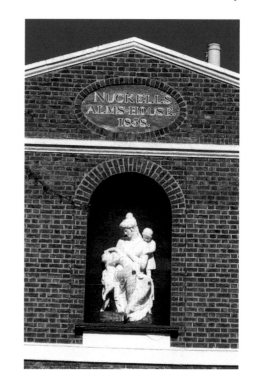

Figure representing Charity on Nuckell's Almshouse.

This pattern of charitable giving continued in the wills of Mary and Ann, in which they both endowed charitable institutions that still exist in Broadstairs to this day.

A Board of Education report on endowments for the years 1853 to 1894 reveals the details. When Ann died in 1843, the report notes, her will left instructions that, upon her sister Mary Pearson Strong's death, the sum of £5,000 should be invested and the income used to support or establish three schools in Broadstairs: an infants', a girls' and a boys' school. The money was expressly to be used 'for the purpose of educating the children of the poor in religious and useful knowledge … and towards the clothing [of] such children of the said schools', and to help them become 'good and profitable servants and labourers'.

Ann left it up to the vicar of St Peter's, John Hodgson, to decide exactly where and how the money should be spent. The Board of Education report adds that: 'A marginal note to this printed copy states that the then intention of the vicar of St. Peter's was to divide the income in equal proportions among the six schools built during his incumbency in the parish of St. Peter, namely, a Boys' School, a Girls' School and an Infants' School in the District of Broadstairs, and a Boys' School, a Girls' School and an Infants' School at St. Peter's proper.'

When Mary Pearson Strong died in 1855, her will left money for the improvement of St Peter's Church and 'for the benefit of the Girls' School at St. Peter's … and of the inmates or any of them in Nuckell's Almshouse'. Shortly afterwards, in 1858, Nuckell's Almshouse was radically rebuilt, creating the grand Palladian-style Grade II-listed building to be seen today, with its niche holding a sculpture of a mother and children, representing Charity.

The Nuckell and Pearson Strong grave at St Peter's.

IN MEMORY OF
MARY PEARSON
STRONG,
OF BROADSTAIRS,
WHO DIED JANY 14TH
1855,
AGED 84 YEARS.
"GIVE ALMS OF SUCH
THINGS AS YE HAVE"

Mary Pearson Strong's inscription.

Mr Wood confirms: 'Together with a few others, Nuckell's Almshouse benefits from a small charity of Mary Pearson Strong. I understand that Miss Strong also paid for a girls' school to be added to St. Peter's Infants school in the village ... Nuckell's Almshouse still houses "poor" people. The building is now arranged in six self-contained flats – one two-bedroomed and five with one bedroom. The residents help towards the upkeep of the premises by paying a weekly maintenance contribution.'

DID YOU KNOW?
From the mid-nineteenth century until the late twentieth a succession of small safety boats were on hand for swimmers who got into danger in Viking Bay. Frank Muir, in his autobiography *A Kentish Lad*, remembers 'a retired salt of great age slumped asleep over the oars' in the 1920s. In the 1890s the safety boat had served a second purpose: to keep male swimmers away from the ladies' bathing machines that were placed closest to the pier. In 1969, future Prime Minister and Broadstairs native Sir Edward Heath launched a new inflatable safety boat, the *Stella Maris*.

Charities in the names of Mary Pearson Strong and Nuckell's Almshouse still exist. The charitable object of the Mary Pearson Strong endowment, as the current Charity Commission listing makes clear, is little changed. It is to provide 'Almshouses for poor persons of good character who are members of the Church of England and who have resided in the Isle of Thanet for not less than seven years ... with preference to persons who have so resided in the ancient parish of St. Peter.' It is linked with the Nuckell's Almshouse charity.

Mary's inscription on the family tomb in St Peter's churchyard reads: 'Give alms of such things as ye have'. Ann's records that she died 'bequeathing large sums to pious and charitable uses in this parish. Founder of Nuckell's Alms-house'. Inflation has eaten away at Mary Pearson Strong's endowment and, says Mr Wood, the charity now receives just £19 per year from this source.

Dickens and Broadstairs' 'Bravest and Most Skilful Mariners'

The concrete facts of Charles Dicken's long association with Broadstairs are recorded on the many plaques dotted around Broadstairs, where he first came at the age of twenty-five and where he wrote parts of *The Pickwick Papers, Nicholas Nickelby, Barnaby Ridge, Dombey and Son* and *David Copperfield*, as well as extensive journalism. Dickens stayed, first, in a cottage at No. 12 High Street, now replaced with a shop and numbered 29; numerous times at the Royal Albion Hotel; in Lawn House, Fort Road (now called Archway House); and latterly in Fort House, later renamed Bleak House. The last of his regular visits – often from May to October – was in 1851, by which time the town had become too noisy for him to work uninterrupted. After an eight-year absence, his final stay was for a week at the Royal Albion in 1859.

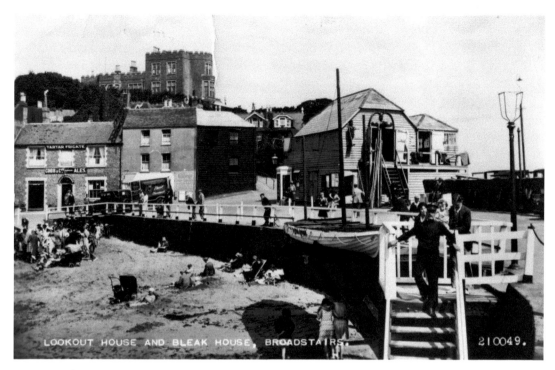

An early twentieth-century postcard of Bleak House.

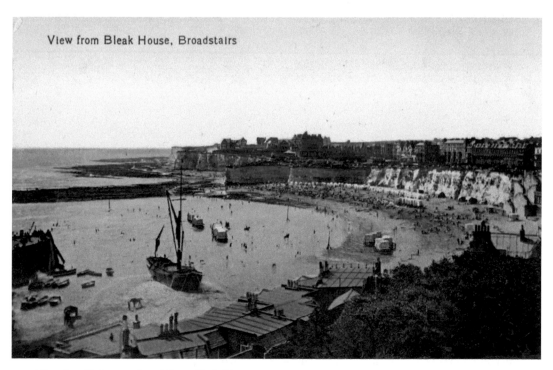

The view Dickens enjoyed from Bleak House.

Dickens plaque on
Bleak House.

Charles Dickens had a strong regard for the fishermen of Broadstairs. In *Our English Watering Place* he wrote:

These are among the bravest and most skilful mariners that exist. Let a gale arise and swell into a storm, let a sea run that might appal the stoutest heart that ever beat, let the light-boat on these dangerous sands throw up a rocket in the night, or let them hear through the angry roar the signal-guns of a ship in distress, and these men spring up into activity so dauntless, so valiant, and heroic, that the world cannot surpass it.

In 1851, during atrocious storms, a steamer carrying livestock to Rotterdam had been wrecked on the Goodwin Sands, with shocking consequences. In letters to friends, Dickens expressed his shock at the aftermath:

Yesterday the shore was strewn with hundreds of oxen, sheep, pigs (and with bushels upon bushels of apples) in every state and stage of decay – burst open, rent asunder, lying with their stiff hoofs in the air or with their great ribs yawning like the wrecks of ships – tumbled and beaten out of shape, and yet with a horrible sort of humanity about them

Hovering among these carcases was every kind of waterside blunderer, pulling the horns out, getting the hides off, chopping the hoofs with poleaxes ... attended by no end of donkey carts and spectral horses with scraggy necks, galloping wildly up and down as if there was something maddening in the stench. I never beheld such a demonical business.

In an action that shows his humanity, Dickens gave the Broadstairs men very practical support:

I stood a supper for them last night, to the unbounded gratification of Broadstairs. They came in from the wreck very wet and tired, and very much disconcerted by the nature of their prize – which, I suppose, after all, will have to be recommitted to the sea, when the hides and tallow are secured.

Characteristically, Dickens also managed to extract a glimmer of humour from the incident:

One lean-faced boatman murmured, when they were all ruminative over the bodies as they lay on the pier: "Couldn't sassages be made on it?" but retired in confusion shortly afterwards, overwhelmed by the execrations of the bystanders.

Fort House and Wilkie Collins

During his final, 1859, visit, Dickens met up with his close friend Wilkie Collins, then writing the book that would make him famous, *The Woman in White.* Dickens first met Collins in 1851, the year of his final family stay at Fort House. The eight intervening years had seen profound changes in Dickens's life.

Collins and Dickens were aged respectively twenty-seven and thirty-nine when they first met. Dickens was writing *David Copperfield,* yet Wilkie was barely launched as a writer. However, they at once took to each other and began a friendship that lasted until Dickens's death in 1870.

William M. Clarke, in *The Secret Life of Wilkie Collins,* says both men had profound personal problems:

Dickens, unhappily married, increasingly conscious of his wife's deficiencies, driving himself into a frenzy of work as a way out, and as quickly needing immediate distractions; Collins, with a relaxed attitude to sexual morality, persuaded of the futility of marriage, avoiding it at all costs, often bent on the good life with an openness that fitted oddly with Victorian morals.

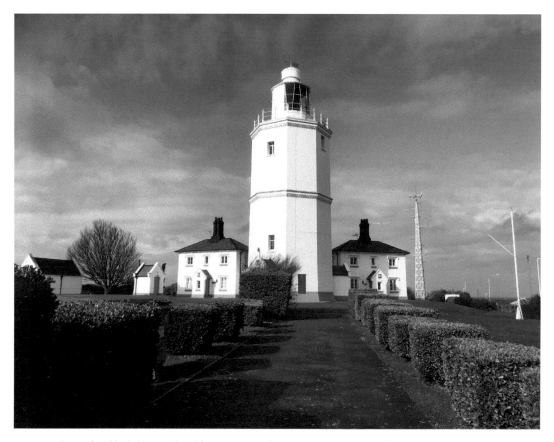

North Foreland lighthouse, the oldest in England and inspiration for Wilkie Collins.

Work and play were inextricably bound together for the two men; Wilkie joined the Dickens family on holidays, and went on writing trips with him. Clarke notes that: 'It was in this period that both met women who were to fashion the rest of their lives, and in ways that reflect their differing temperaments.'

Dickens began an affair with the young actress Ellen Ternan and abandoned his wife. Collins, already in one relationship – with Martha Rudd, who would bear him three children – met Caroline Graves, with whom he also carried on a long affair.

DID YOU KNOW?
A life raft from the Lusitania, the Cunard liner torpedoed by a German U-boat in 1915 with the loss of 1,198 lives, was displayed beside the pier from 1917 until 1949, with a plaque on its mast reading: 'Lest we forget'. In that year it was taken to the council yard for repainting, where a lorry backed into it, damaging it beyond repair.

In 1859 Wilkie and Caroline had taken Church Hill Cottage, overlooking the sea on the Ramsgate Road outside Broadstairs. It was here he began *The Woman in White*. Collins got the title while looking at the North Foreland light house. Clarke reports:

> In despair at finding a suitable title he was walking one afternoon along the cliffs near Broadstairs. He threw himself on the grass as the sun went down and looked up at the lighthouse. 'You are ugly and stiff and awkward', he called out, 'you know you are as stiff and weird as my white woman – white woman – woman in white – the title, by Jove!'

The ties between the two families increased in 1860, when Dickens's daughter Kate married Wilkie's brother Charles – a disastrous marriage that Dickens believed he had driven Kate into – shortly after he left his wife and she looked for a way out of his household.

In summer 1862 Wilkie Collins rented Fort House, Dickens's former favourite, to write his novel *No Name*, using the same desk in the study as Dickens, but he never felt the same affection for the place as a holiday home, preferring to billet his two families in separate houses in neighbouring Ramsgate and to commute between the two.

After Dickens's death Collins avoided Broadstairs because, writes Peter Ackroyd in *Wilkie Collins*, 'it contained too many memories of happier days with Dickens and his family; it had become for him 'the most dreadful place in the word'.

3. The Eccentric King of Kingsgate

Kingsgate: 'Another Name for Paradise'

For Henry Fox, 1st Baron Holland, the idea of seeing a castle on a clifftop when he – or more likely his butler – opened the curtains in the morning held great appeal. So he built one. It's called Kingsgate Castle and it stands proudly on the south headland above Kingsgate Bay.

The castle, designed to mimic a medieval fortification from the reign of Edward I, looks as if it ought to be the grand country seat of a nobleman, but it actually only contained stables for Baron Holland's horses and accommodation for his grooms.

Holland (1705–74) made his actual home just north of it, transforming a modest merchant's house into a mansion he named Holland House. Along with his mock castle he commissioned several other buildings that were not what they seemed, including a 'convent' that was actually additional accommodation for family and guests, and an 'almshouse', which was really a place to entertain those guests, and which later became a pub.

Other constructs were pure follies, without function, related to significant historic events on the land he owned, but also intended to supply attractive ruins to enhance the views from Holland House.

Holland was a leading Whig politician of the eighteenth century, a rival to William Pitt (Pitt the Elder), and tipped as a future prime minister. There were, however, suspicions

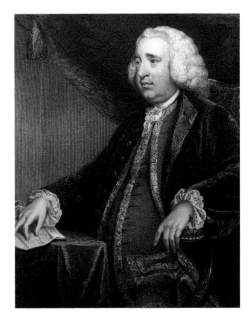

Henry Fox, 1st Baron Holland.

Kingsgate Castle.

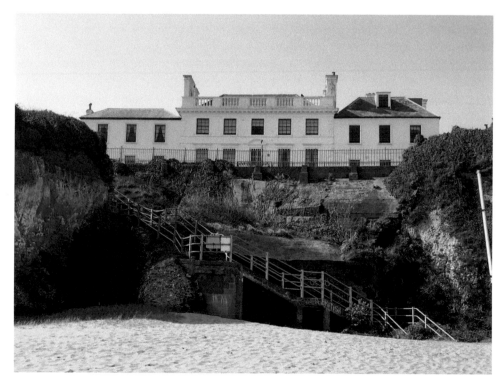

Holland House, Kingsgate Bay.

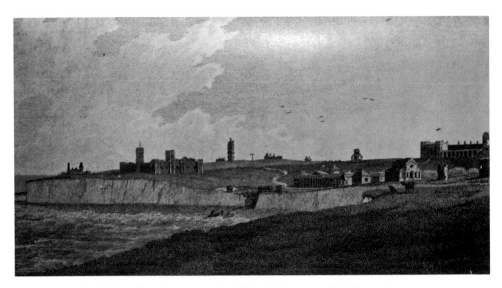

Kingsgate Castle (left), Holland House and St Mildred's Convent. (B. T. Pouncy)

that, as Paymaster General, he syphoned off large sums from the public purse, which he used to fund developments at Kingsgate. In 1744 he persuaded Lady Caroline Lennox, eighteen years his junior, to elope with him. Despite her parents' disapproval, the marriage was a happy one. He had another mansion, also called Holland House, in Holland Park, Kensington, but sought out a healthy home on the coast where the sea cure would ease his severe asthma, gout and rheumatism.

When Holland discovered Kingsgate in May 1762 it was a remote and barren place. His biographer, the Earl of Ilchester, writes in *Henry Fox, First Lord Holland*: 'At that time the promontory of the North Foreland afforded scant attraction to the traveller, and Holland had that remote corner of Kent completely to himself'.

The baron's friends told him moving here amounted to 'sea madness' but he declared Kingsgate 'another name for paradise'. By August he was reporting: 'My expectations cannot exceed what I have found here. Appetite, sleep, continued cheerfulness and quiet, all within 30 yards of the sea, and often in it ... We have been out catching whiting and trawling for flat fish almost ev'ry day.'

He set about transforming the property, modelling it on Tully's Villa at Formia, on the coast between Rome and Naples. Tully – Marcus Tullius Cicero (106 BC–43 BC) was a Roman statesman, lawyer and scholar, and one of classical Rome's greatest orators. In imitation of Tully's villa, Holland House had a central grand Doric portico with twelve columns of Portland stone, buttressed by north and south wings in knapped flint. William Henry Ireland in *England's Topographer* adds: 'wile over the doorways are two basso-relivos in white marble. The principal apartment is a detached saloon, the ceiling decorated by a painting of the story of Neptune, supported by columns of scagliola marble, in imitation of porphyry,' which is a deep-purple igneous rock containing large crystals.

The neoclassical architect Robert Adam was consulted on the design, but Fox decided his plans were too grand. He preferred the ideas of Thomas Wynne, which were 'amateurish but more homely'.

'Within', says James E. Bird in *The Story of Broadstairs and St Peter's* 'was a fine collection from Italy of marbles, vases, busts and statues, put ashore at his own landing stage' in Kingsgate Bay.

There were other historical references in what Holland and Lady Caroline created at Kingsgate Bay. A key one was the creation of a grand gateway guarding the approach through the cliffs to the house. Until the late seventeenth century this was called St Bartholomew's Gate because, legend has it, the cliff face was torn open by an earth tremor on St Bartholomew's Day, 1500.

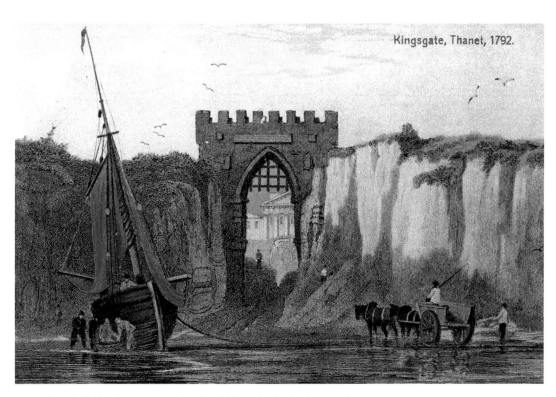

Kingsgate, Thanet, 1792.

The King's Gate in 1792, with Holland House in the background.

It was renamed Kingsgate because, on 30 June 1683, Charles II and his brother the Duke of York, later James II, were driven ashore here during a storm while on their way to Dover. The king ordered it to be renamed in thanks for his deliverance from the storm. The fact, says Ilchester, that there had once been a rampart and portcullis erected here to curb the nefarious activities of smugglers 'put original ideas into the head of the new owner'. Inevitably inspired in part from the fact that his wife Caroline was a great-granddaughter of Charles II, he built an imposing castellated gateway.

Holland House was certainly grand – far grander in appearance than it is today – but Fox didn't want it to be too large, so he looked around for additional accommodation. Around 300 yards inland from the house were the ruins of a convent – dedicated to St Mildred, the patron saint of Thanet – and destroyed during the Dissolution of the Monasteries under Henry VIII. In 1764 Fox restored and greatly expanded it, adding a cloister, renamed it Port Regis (the Latin for King's Gate), and used it for family and guests.

On the north side of the bay, between 1763 and 1768, Fox built a mock bede, or almshouse, actually a place for drinking and entertaining, named The Noble Captain Digby, after his nephew Robert Digby (1732–1815), who commanded a warship of the English fleet and later became an admiral. The Captain Digby had become a pub by 1809. In 1857, fourteen sailors rescued from the wreck of the *Northern Belle* were brought here to recover.

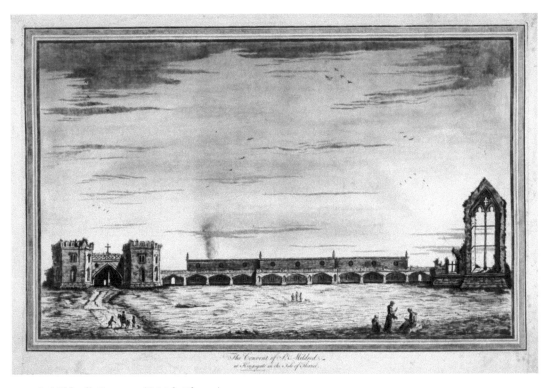

St Mildred's Convent. (British Library)

DID YOU KNOW?
In April 1952 a United States Air Force Thunderjet, stationed at RAF Manston, crashed in St Peter's, destroying Lloyds Bank and C. J. Elliott's ironmongers, and bursting into flames. Four people were killed, including the pilot, but casualties might have been far greater if the accident had happened a few minutes later, when the congregation would have been leaving St Peter's Church.

The other constructions had no purpose other than looking fine and marking historic events. On the heights overlooking the south side of the bay was a Saxon burial mound, which Holland believed to date from a battle between the Saxons and Danes in around 850. In 1765, he had the mound excavated and numerous skeletons were discovered, confirming him in his view. Holland built Hackendown Tower, apparently a play on 'hack 'em down', on the site to commemorate the battle. A Latin inscription on it translated as:

To the shades of the departed and in memory of the Danes and Saxons who were killed here whilst fighting for the possession of Britain (soldiers think everything their own), the Britons already having been perfidiously and cruelly expelled, this was put up by Henry Holland. History does not record the names of the leaders or the result of the action. It happened about the year 850 and that it happened here seems true from the quantity of bones buried in this and the nearby tumulus.

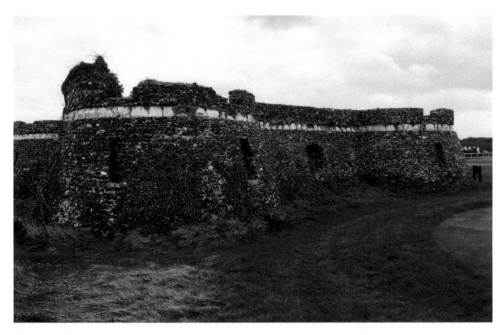

Neptune's Tower today.

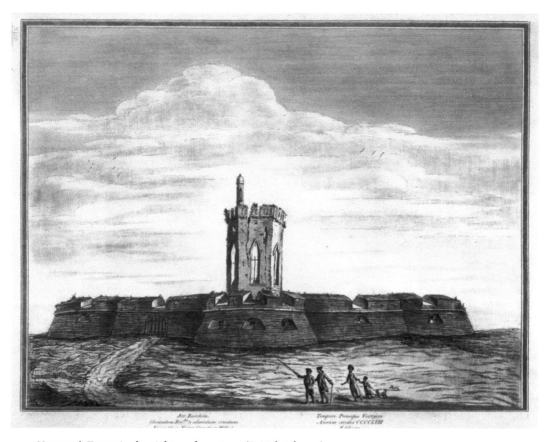

Neptune's Tower in the eighteenth century. (British Library)

On the northern headland beyond the Captain Digby stood a stone tower, Arx Ruochim, which may have dated from the sixteenth century and which Holland liked to believe replaced a much earlier tower erected here by Vortigern, king of Kent, in 458. He built around it a small castle rather in the style of one of Henry VIII's Martello Towers. Hasted, in his *History of the County of Kent* of 1800, described it as a Temple of Neptune, and it is believed to have contained a statue of the god.

There were other follies, including the Countess Fort, built between the castle and the sea and intended as an icehouse but never finished, and Whitfield Tower, known locally as The Candlestick. It was built in a field near Reading Street, on the highest point locally, in memory of Robert Whitfield, from whom Holland had bought the land for his estate.

This remarkable creation hit dark times when Holland died in 1774. Holland left Kingsgate to his second son, Charles, who, as well as being a prominent Whig politician like his father and a great rival to William Pitt the Younger, was also a notorious gambler.

Charles had always been spoilt. Amanda Foreman, in her book *Georgiana, Duchess of Devonshire* – about the political activist, notorious socialite and close friend of Charles Fox – says of his upbringing: 'By contemporary standards the Holland household was a kind of freak show. There were stories of Fox casually burning his father's carefully prepared speeches, smashing his gold watch to see how it would look broken, disrupting dinners – and never being punished.'

Henry Holland's 'last act before dying was to pay off his son's £140,000 debts'. Yet, by 1777, Charles was again so indebted that he had to sell Kingsgate, ending an era of great, eccentric creation on the cliffs above the bay. The rest of its story is largely one of decline.

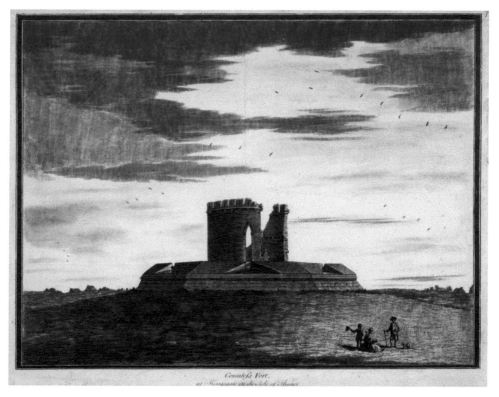

Countess Fort.

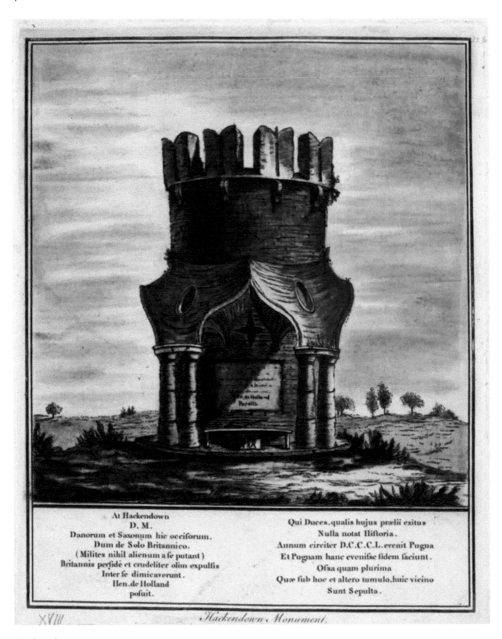

At Hackendown
D. M.
Danorum et Saxonum hic occiforum.
Dum de Solo Britannico.
(Milites nihil alienum a fe putant)
Britannis perfidè et crudeliter olim expulfis
Inter fe dimicaverunt.
Hen.de Holland
pofuit.

Qui Duces, qualis hujus prælii exitus
Nulla notat Hiftoria.
Annum circiter D.C.C.C.L. evenit Pugna
Et Pugnam hanc evenifse fidem faciunt.
Ofsa quam plurima
Quæ fub hoc et altero tumulo, huic vicino
Sunt Sepulta.

Hackendown Monument.

Hackendown.

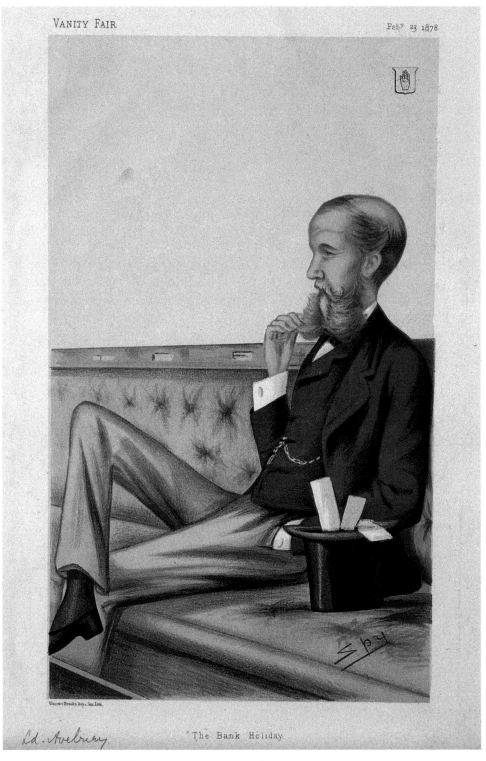

Ld. Avebury "The Bank Holiday"

Lord Avebury, caricatured by Spy in *Vanity Fair,* 1878.

Kingsgate in Decline

Kingsgate and its many hundreds of acres, which included the Quex estate at Birchington-on-Sea, was sold first to John Powell, Baron Holland's friend and executor, but he died in 1783 and it passed to his sister and her family. A succession of owners followed, and all the while Kingsgate declined, the estate broken up into its constituent parts.

In 1900 Kingsgate Castle was bought by another prominent man. John Lubbock, 1st Baron Avebury (1834–1913), was a banker by profession but, as an amateur archaeologist, he did some remarkable things. He coined the terms Palaeolithic (when humans were nomads using primitive tools) and Neolithic (when the discovery of agriculture allowed a settled existence) to differentiate the old and new Stone Ages, and helped establish archaeology as a scientific discipline. He was also an MP, sitting for Maidstone from 1870, and introduced a number of reform bills including, in 1871, the Bank Holiday Act.

Avebury enlarged Kingsgate Castle and made it his residence. Only the round tower remains from the original building. After Avebury's death, the castle and 124-acre grounds were sold to Lord Northcliffe, proprietor of the *Daily Mail,* about whom we will learn a good deal more in the next chapter. On part of the grounds Northcliffe established the North Foreland Golf Club, and the castle became a smart hotel, where stars including John Mills and Peggy Ashcroft stayed. It is now divided into thirty-two flats.

While the castle remains intact from this time, Holland House has been less fortunate. By 1839 part of it had become a coastguard station, and the imposing portico was removed to adorn the Royal Sea Bathing Hospital at Margate. It is now divided into flats.

What of the King's Gate itself? Ilchester says: 'The gateway with its cyphers and coats of arms designed to remind the passing guest of the visit of King Charles, the chatelaine's great grandfather, has been transported to the Convent gardens, and is re-erected near the [Saxon burial] mounds.' It looks much less imposing than in engravings of it in situ by the cliffs. It has lost its crenellations but does still bear the insignias of Charles II and his brother the Duke of York.

The 'convent' of Port Regis became a boys' school in 1921, having been bought by Sir Milsom Rees, George V's laryngologist. After the war, Port Regis finally became an actual convent, run by the Belgian order the Daughters of the Cross. Today it houses a retirement home and a Montessori nursery school. Whitfield Tower collapsed in a gale in 1978.

The Captain Digby became a victim of coastal erosion, and much of it fell over the cliff in 1861. Some of the building material was salvaged and incorporated in the new building, built further back from the edge. However, the square, crenellated structure that stands on the cliffs today looks very different to the original building, with its pitched roof and gable topped with a cross.

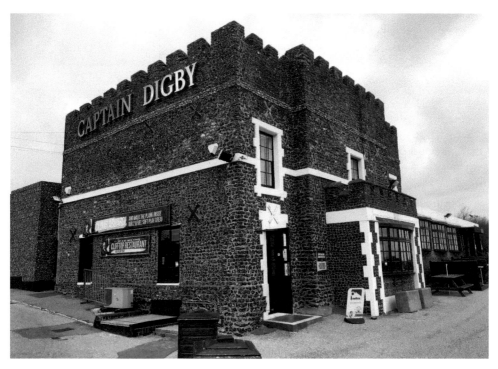

The Captain Digby today.

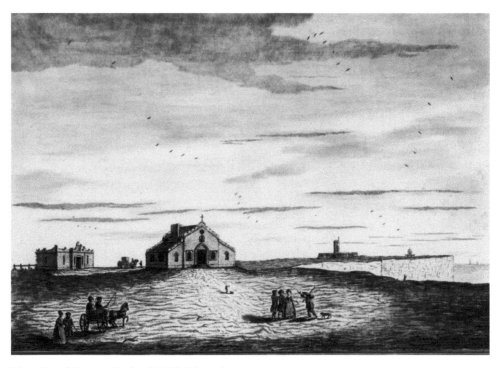

The original Captain Digby. (British Library)

4. War and Spies, Truth and Lies

The climax of one of the most celebrated spy novels of all time famously takes place in Broadstairs, but there is also a little-known – and equally compelling – story of fascist spying and conspiracy to be uncovered at almost exactly the same spot on the North Foreland. There is also the allegedly true story of how Lord Northcliffe, proprietor of the *Daily Mail*, was very nearly assassinated by the Germans at his home in Reading Street. As we shall see, there is a good deal more to that tale than meets the eye.

John Buchan and *The Thirty-Nine Steps*

It was 2 August 1914 and the world was about to change forever. In two days, the Kaiser's troops would fail to withdraw from neutral Belgium, and on 5 August Britain would declare war on Germany. Not a good time, then, for John and Susan Buchan to arrive at Broadstairs on holiday.

An early edition of *The Thirty-Nine Steps*.

John Buchan (from *The Country Gentleman and Land & Water* magazine).

The Buchans were here on doctor's orders. Their six-year-old daughter Alice had been prescribed sea air to aid her recovery, following a mastoid operation. Mastoiditis, an infection of the inner ear, was then a leading cause of child mortality, and the couple were extremely worried about their daughter. They had booked rooms at St Ronan's guest house, No. 71 Stone Road (later renumbered No. 83 and demolished in the 1970s). As Susan would later write, arriving 'about two days before war was declared' was pretty bad timing. 'We had some quite nice lodgings ... and should have enjoyed ourselves, as Alice's health improved all the time, but the war precluded all happiness and comfort.'

Another grave worry was also on the horizon. It quickly became apparent that John Buchan was seriously ill. Intense stomach pains – later to be diagnosed as a duodenal ulcer – laid him up in bed.

Buchan, an always-busy barrister and chief literary adviser to the publisher Thomas Nelson, resorted, as he often did when bored or in need of distraction, to writing fiction. He had already published one thriller, or 'shocker' as he called them, and began to piece together ideas for a spy novel. He drew on a febrile atmosphere of the time – fear of enemy spies was widespread – and the place he was in: the bays around the North Foreland were the perfect spot for enemy agents to slip in or out of the country.

Buchan was by nature a man of action and would much rather have taken an active role in the conflict. In his autobiography *Memory Hold-The-Door* he wrote: 'I was thirty-nine and consequently well over the age for enlistment, and in any case no recruiting office would accept me.'

Instead he moved to recuperate in a clifftop villa, St Cuby, on the corner of Anne's Road and Clifftop Promenade, North Foreland, where Susan's cousin Hilda Grenfell and her family were staying. There, Buchan wrote, 'I went to bed for the better part of three miserable months, while every day brought news of the deaths of my friends ... while pinned to my bed during the first months of war and compelled to keep my mind off too tragic realities, I gave myself to stories of adventure.'

To distract himself: 'I invented a young South African called Richard Hannay' who, in the novel he would call *The Thirty-Nine Steps*, 'was spy-hunting in Britain'.

Buchan's surroundings seeped into the novel. Broadstairs became Bradgate – a combination of Bradstowe, the old name for the town, and Kingsgate. The headland of the North Foreland became The Ruff. In the novel we read of 'The big chalk headline in Kent, close to Bradgate. It's got a lot of villas on the top and some of the houses have staircases down to a private beach. It's a very high-toned sort of place, and the residents like to keep by themselves.'

St Cuby became Trafalgar Villa where, in the book's climax, the villains are cornered by Hannay and try to make their escape down a tunnel through the cliffs opposite the house to the beach, where a boat awaits them, descending what many believe to be those famous thirty-nine steps.

Or are they? One of the themes of suspense in the book is the race to correctly identify the set of steps. As Hannay says as he hunts for the correct location: 'If one of those staircases has thirty-nine steps we have solved the mystery, gentlemen.' In fiction as in reality, the obvious is not always the correct answer.

Certainly the steps generally believed to be the originals are conveniently located, but there is one key anomaly: there are not thirty-nine of them. Today access is blocked from the top of the cliffs, but the steps are accessible from the beach at low tide. In 1914 there were seventy-eight oak and stone steps, replaced in the 1940s with 115 concrete ones. One theory is that Buchan halved the number seventy-eight, simply because it made a better title. Another is that he was conscious of his age – thirty-nine.

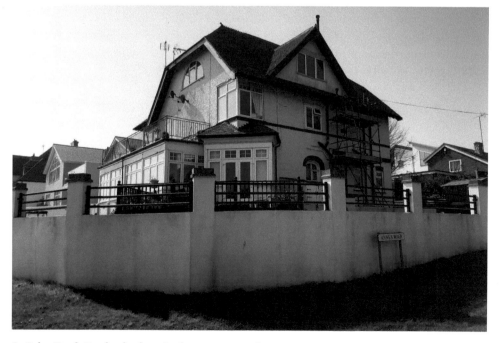

St Cuby, North Foreland, where Buchan recuperated.

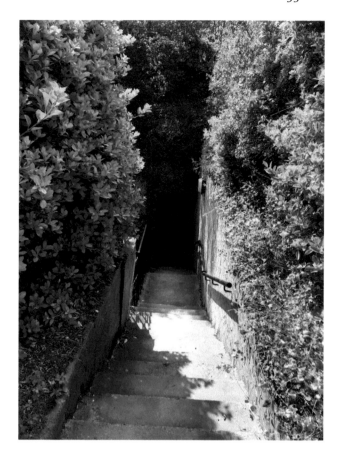

The clifftop entrance to the steps.

The entrance to the steps from the beach.

A further explanation comes from his son, William Buchan, who wrote in *John Buchan: A Memoir* that the origin of the thirty-nine steps '[has] been the subject of great debate, but ... my sister, who was about six, and who had just learnt to count properly, went down them and gleefully announced: there are thirty-nine steps.' When the steps were removed, John Buchan was sent a section with a brass plaque attached to it.

DID YOU KNOW?
Another real-life Broadstairs spy story involves Dr Hermann Goertz, who, in 1935, rented a bungalow called Havelock in Stanley Road together with nineteen-year-old Marianne Emig. She befriended Kenneth Lewis, a young airman on leave from Lee-on-Solent, asking him to send her pictures of planes and aerial views of his base. He sent her picture postcards. When Goertz's landlady became suspicious, the bungalow was raided while her tenants were away in Germany, and a spy camera and documents about RAF bases discovered. Goertz was caught and sentenced to four years in prison, but Emig was never found.

Could one of these theories hold the answer? There is some evidence to suggest that the real model for those steps was a little further north along the coast from St Cuby, at Kingsgate Castle.

Arthur C. Turner, a close friend of the Buchans, wrote a memoir of the author – *Mr Buchan, Writer* – in 1949, dedicating it to Susan Buchan. In it he says 'Buchan took pleasure in

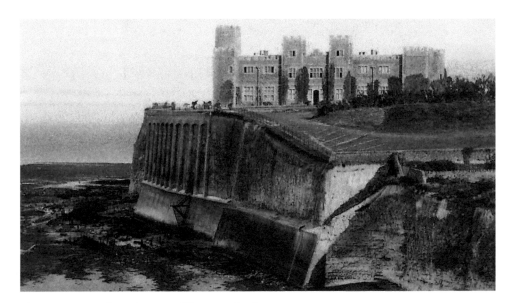

The since removed metal steps at Kingsgate Castle.

using some scenes close to hand, for the climax of the story takes place in a cliff-top villa in Broadstairs itself ... and the original of the famous staircase led down to the sea from Kingsgate Castle.' There is no evidence of Buchan, or his wife, ever challenging this statement.

Photographs from the period show there was indeed a set of iron steps, in three sections, leading up from the beach to an iron door in the reinforced cliff face, which have since been removed. From 1913 the castle had become a smart hotel, and behind the door was a staircase cut through the chalk that led up to the castle's showers, used by guests after a swim on the then private beach. The stairs may have been added in 1860, when the sea wall was built, shoring up the eroding cliffs beneath the castle.

These steps fit the description in the book more closely than those opposite St Cuby's in one distinct way: they were in the open air and visible from the cliff top, the 'regular staircases' described in the novel, rather than being hidden in a shaft cut through chalk cliffs as at St Cuby. Examinations of blown-up photographs show that there were approximately thirty-nine of them.

Kingsgate Bay was long favoured by smugglers over Stone Bay, beneath St Cuby, because it is more remote and has a sandy shore rather than the rocky beach at the latter. Spies would favour it for the same reasons.

It is clear from the novel that Buchan was aware of this location. Scudder, the character who first alerts Hannay to the existence of the steps, disguises himself for a time as Captain Digby, which is the name of the pub across the bay from Kingsgate Castle. Also, while keeping Trafalgar Lodge under observation, Hannay sees a man with a set of golf clubs riding a bike. North Foreland Golf Course is adjacent to Kingsgate Castle.

Arthur Tester: The Real-life Fascist of North Foreland

There is a house with truly sinister and genuine connections to fascists, spies and Nazis just a few doors along from St Cuby. It is called Naldera and what happened there is every bit as dramatic a real-life story as the fiction spun by John Buchan.

No one took the Broadstairs branch of the British Union of Fascists (BUF) particularly seriously, despite the fact that, in 1936, five of their number were fined £14 for attacks on a Jewish shop in Margate. They had a meeting place in the High Street with a swastika in the brickwork – it is still faintly legible – and paraded through the town in their black shirts.

Their leader, Dr Arthur Tester, was more dangerous than he might have appeared in the years before the outbreak of the Second World War, when appeasement was the favoured option for dealing with Hitler, and when William Joyce, in the future to become infamous as the Nazi propagandist Lord Haw-Haw, taught at Port Regis school in Kingsgate.

In 1930, Tester bought the twenty-room clifftop mansion for £6,000 and lived there with his wife Charlotte, a former nightclub singer, and their six children. He bought several other properties in the area, and had a 245-ton luxury steam yacht, the *Lucinda*, moored in Ramsgate Harbour. He was ostentatious, flamboyant, wore expensive suits and a monocle, the sort of person who attracts attention as a way of hiding in plain sight. He had many servants at Naldera, including Cecil Cayzer of Vere Road, St Peter's, as chauffeur and bodyguard. His collection of cars, one a Studebaker, flew pennants featuring the lightning flash in a circle of the BUF.

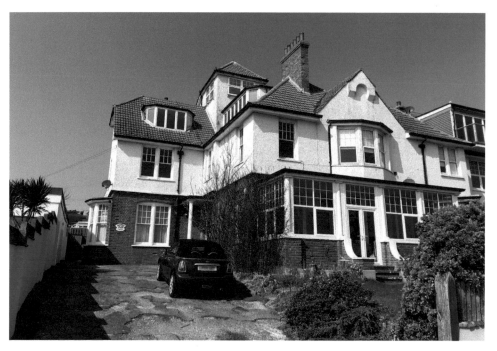

Naldera, Dr Arthur Tester's house on the North Foreland.

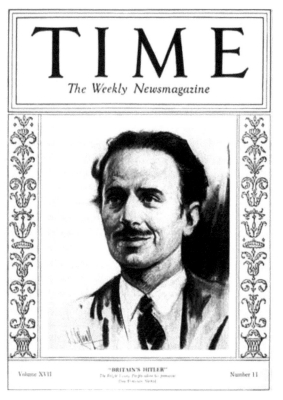

Oswald Mosley, said to have visited Tester at Naldera.

There were stories that he entertained prominent Nazis including Ribbentrop at his house and on his yacht, and was regularly visited by Sir Oswald Mosley, founder of the BUF. Tester claimed to be Mosley's personal aide-de-camp. It was also said that there were portraits of Hitler on Naldera's walls, and a nudist colony behind the tall hedges.

By a strange coincidence, Naldera had been built for Lord Curzon, Viceroy of India, whose daughter Cynthia had married Oswald Mosley in 1920. The house, which Curzon named after a favourite Indian hill station near Simla, had lain empty since his death in 1925.

Tester established a string of dummy companies, including British Glycerine Manufacturers, Paramount Restaurants, and various engineering, arms and car-making businesses. Their actual purpose was to syphon money from British sympathisers to fascist parties and groups in Europe. He also set up the European Press Agency, covertly funded by the German government, which circulated anti-communist and anti-Semitic bile provided by the German Propaganda Minister Joseph Goebbels.

DID YOU KNOW?
When the newly wed Hollywood stars Douglas Fairbanks and Mary Pickford found their 1920 honeymoon in London being ruined by hordes of admirers, Lord Northcliffe offered them Elmwood Cottage in Reading Street as a romantic hideaway. Unfortunately, word got out and Mary opened the curtains to find a line of fans watching her from on top of the high brick garden wall. They promptly applauded the sight of her in her nightdress.

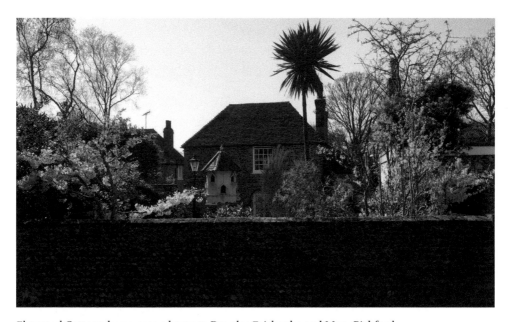

Elmwood Cottage, honeymoon home to Douglas Fairbanks and Mary Pickford.

Some believe Tester's importance has been exaggerated, arguing that he was a con man who routinely created front companies before declaring bankruptcy and stealing the profits. One theory is that Mosley, who was always dreaming up money-making schemes, got Tester to set up the scams, but that Tester ripped him off, keeping the cash generated for himself.

In 1938, investigations by the *Daily Express* led to questions being asked in Parliament about Tester's European Press Agency being run from Berlin. Tester panicked, fleeing from North Foreland with his family, by some accounts down the very flight of steps that John Buchan had woven into the climax of his spy drama, before boarding his yacht. The yacht was later seized in Naples while Tester was visiting Mussolini in Rome.

Tester surfaced in Romania, where he was a German army interrogator. In 1942 he approached the German ambassador in Bucharest, offering to broadcast propaganda to Britain and organise the liberation of Mosley, who had been interned. The offer was rejected by Joachim Ribbentrop, the German Foreign Minister.

In September 1944, London newspapers reported that Tester had been shot dead by border guards as he tried to move from Romania to Hungary, carrying a passport signed by Hitler. After the war the rumours that he had faked his own death were such that his remains were disinterred and dental records held by his Ramsgate dentist, Brigadier J. Morley Stebbings, consulted to prove the body was his.

What of Naldera? During the Second World War the house, despite being shielded behind barbed wire, was extensively looted. In 1946, the *Thanet Gazette* carried an announcement of an auction of its contents 'consisting mostly of luxury goods in almost new condition'. A 'full size cocktail bar complete with hide upholstered easy chairs and stools' and reputedly decorated with swastikas went for £288. In all, the sale, which also included a Steinway electric grand pianola and 'oil paintings reputed to be by Turner,' fetched £9,000.

Naldera is now divided into flats.

The 'Plot' to Assassinate Lord Northcliffe

At 11.30 at night on the 25–26 February 1917, a German destroyer slid to within a mile of the coast at Kingsgate with a special mission direct from the Kaiser: to kill the proprietor of the *Daily Mail,* Alfred Harmsworth, Lord Northcliffe, by shelling his house.

Or, at least, that's the story Northcliffe told, and which has been picked up and repeated by his biographers to this day. Is it true? His account deserves a closer look.

Firstly, is it plausible that the Kaiser would target Northcliffe personally? What had the owner of the *Daily Mail, Daily Mirror, The Times, Evening News* and *Weekly Dispatch* done to upset the German ruler?

Convinced that an apathetic Britain faced her biggest foe since Napoleon, Northcliffe's newspapers had thundered for years about the threat Germany posed to peace in Europe. In *Mailmen: The Unauthorised Story of the Daily Mail* Adrian Addison writes: 'The *Daily Mail's* theme from the very start of the war was, in effect, that Germany be annihilated, with the charge being led by Northcliffe himself.' He wanted it 'crushed, penniless'. Lloyd George, in recognition of how much Northcliffe had done to help bring him to power, made him Minister of Propaganda.

Lord Northcliffe on his North Foreland golf course.

Elmwood House, Reading Street.

The Kaiser and the German high command took the *Mail* attacks personally. Addison writes that the German newspaper *Vossische Zeitung* credited the part Lord Northcliffe and his powerful publications had played in Britain's war efforts, 'especially during the Battle of the Somme'. Three months after that bloody battle, Addison concludes, the Kaiser decided to take a very personal form of revenge. 'Silencing the press baron', Addison writes, 'must have been the mission'.

Accepting for a moment that the Kaiser might have wanted Northcliffe dead, could it be done? Shelling his house, Elmwood, in the hamlet of Reading Street, was no easy objective. It was a mile inland and surrounded by other buildings.

Certainly, on the night of 25–26 February 1917, an attack did take place. Northcliffe wrote in his daily staff communique:

At 11.30 my house was lit up by twenty star shells from the sea, so that the place was illuminated as if by lightening. Shrapnel burst all over the place, some of it hitting the library in which these notes are prepared every day, and killing a poor woman and baby within 50 yards of my home and badly wounding two others. The bombardment lasted from six to ten minutes according to various estimates and was the result of a destroyer raid. The authorities have no doubt that my house was aimed at and the shooting was by no means bad. I understand that the destroyer was three miles out.

Northcliffe portrayed himself as the hero of the hour: 'During the bombardment', Addison writes, 'Northcliffe had refused to get out of bed, telling his secretary, "If we are to die, we will die in our beds". Northcliffe would later frequently be seen peering out from a gap in the fence at Elmwood and down to the North Sea [actually the English Channel]. His refuge must never have felt quite the same again.' However, the press baron continued to live here until his death, aged fifty-seven, in 1922.

DID YOU KNOW?
In August 1955 a killer on the run was cornered at Broadstairs harbour. United States airman Napoleon Green, based at RAF Manston, ran amok with a rifle, shooting ten people, three of them fatally, before hijacking a car, which he abandoned outside the Tartar Frigate, where a seventy-year-old parking attendant yelled at him 'You can't park there!' Green shouted back: 'If they want me they will have to come and get me,' before running onto the beach, holidaymakers scattering before him. Shots were fired at him from the clifftop, but Green died by his own hand, shooting himself through the heart at the water's edge.

To read Northcliffe's account, you would assume that all the shells in that raid were targeted at his house, with a few going wide of the mark. However, that is not the case.

In 1919 the *Thanet Advertiser* published a booklet, *Thanet's Raid History*, in which a full account of the attack is given. It paints a very different picture, with around forty missiles raining down over a very wide area.

On 25 February, 1917, Margate and Broadstairs were subjected for ten minutes to a reckless and furious bombardment from enemy destroyers which had found the impenetrable darkness of the night a favourable opportunity for approaching the Kentish coast.

To the unnatural glare of star shells which illuminated the whole of Thanet with a dazzling brilliance, was added the flash of gunfire, the whistling of shells through the air and the sound of bursting shrapnel. Nevertheless, it is wonderful to reflect that though for ten, tense, vivid minutes shells rained upon the habitations of Margate, not a single casualty occurred there and the material damage was estimated to be less than half the amount effected a few months earlier, in one minute, by a few bombs from a solitary seaplane.

At Reading Street, St Peter's, (near Broadstairs) however, one shell, which crashed through the side wall of a cottage, brought death and despair to a large household. The cottage, which was occupied by Mr [Frank] and Mrs [Daisy] Morgan and six young children, is one of two picturesque buildings standing together in a slight hollow a little way back from the main highway, directly exposed to the sea and about a mile distant from the North Foreland lighthouse.

In the upper part of the dwelling, where mother and children slept, the fatal shell exploded within three feet of Mrs Morgan, who was killed instantaneously. Her baby daughter, Phyllis, was found by the father clasped to her breast amongst the debris, and died an hour afterwards. The frantic mother's first thought had evidently been for her youngest born but death, swift and terrible, came while she was attempting to reach the lower part of the house. Three other children of the family were injured and Doris, aged nine, died later at the Margate Cottage Hospital.

This and other accounts make it clear that the true target of the missiles that struck around Reading Street was most likely to have been the North Foreland lighthouse.

Rosemary cottage, in which the Morgan family lived, still stands, set back from Reading Street and at right-angles to the road, just opposite Elmwood. The damage caused when the fatal shell blasted through the cottage wall was not filled in with flint. A round window was placed there, as a mark of what happened that fateful night. Lord Northcliffe, whose car had taken the injured to hospital, contributed £25 to a relief fund set up for the bereaved family.

5. Three Giants of Children's Fiction

Two hugely successful children's authors and one pioneering children's publisher made their homes in Broadstairs: Charles Hamilton, who, as Frank Richards, invented Billy Bunter; Oliver Postgate, creator of TV shows *The Clangers* and *Bagpuss*; and Edwin J. Brett, an immensely successful originator of periodicals for boys who, in 1866, founded *Boys of England*, the first paper aimed at the newly literate lads of the lower middle classes.

Edwin John Brett (1827–95)

Oaklands Court, Vicarage Road, once home to pioneering publisher Edwin Brett.

Jack Harkaway, hero of *Boys of England,*
Brett's massively popular periodical.

Today, there is nothing to suggest that Oaklands Court, an unremarkable, white-painted house in Vicarage Road, St Peter's, was ever the grand residence of a pioneering, self-made Victorian.

Yet, from 1866, this was the country home of Edwin Brett, whose London residence was Burleigh House in The Strand. Oaklands, as it then was, stood in six landscaped acres and contained priceless art and an unparalleled 1,000-piece collection of arms and armoury built up over thirty years. Brett, together with his wife Eliza and nine children, spent at least six months of each year here.

In 1894 *Sala's Journal* printed a breathless account of its splendours:

> The drawing room is a spacious and lofty apartment and most sumptuously furnished. The chairs and lounges are of Louis Quatorze period, and the rich gilding tones admirably with the choice mirrors and chiffoniers and the valuable collection of Dresden, Chelsea and Derby china. In this room, too, there is a clock which was exhibited in the Exhibition of 1851...
>
> On the walls are a number of paintings by old and modern masters ... There is a full length of James II ... while at the foot of the staircase ... is a Van Dyck.

Visitors included the actor Henry Irving and publishing barons Henry Mayhew, co-founder of *Punch,* and Herbert Ingram, founder of *The Illustrated London News.* Brett presented a copy of the book he wrote cataloguing the splendours of his collection to Queen Victoria. It is still in the Royal Collection.

There is nothing in Brett's background to suggest he would achieve so much. Born to an army family in Canterbury, he was apprenticed at fourteen to a watchmaker and, at sixteen, was an engraver for Henry Vizetelly's *Pictorial Times.* He moved on to become a manager for the Newsagents' Publishing Company where, says Richard Lewis, in *Discovering More Artistic Thanet,* 'Under his management the company developed a new sub-genre in penny dreadful fiction that placed juvenile heroes in tales of sensational brutality.'

While he found his first success with them, Brett aspired to do something better, and came up with a periodical that, says Christopher Banham in *Boys of England and Edwin J. Brett, 1866–99* 'boasted a heady mix of exciting fiction, informative non-fiction, vivid illustrations, and free gifts and competitions, all delivered with refreshing conviviality. The paper was large, and a full 16 pages long, yet cost only one penny. It proved enormously popular, chiefly amongst working-class boys, and would make him immensely rich.'

Within a few years, Brett struck out on his own, forming his own publishing company. None too soon, as shortly afterwards his former employer was raided by police and closed down over 'public concerns over its glamorising of crime and violence'.

Boys of England appeared weekly from 1866 to 1899. Within five years it was selling 250,000 and sparked a publishing revolution. Hundreds of periodicals imitating it were issued over the following decades, although none matched its success.

DID YOU KNOW?
After Bunter author Charles Hamilton's death, his extensive library was dismantled by Robert Acraman and transferred to his flat in Kingsgate Castle, where he created an informal Hamilton museum. There can be no truth, however, in speculation that Hamilton based the layout of Greyfriars' School on Kingsgate Castle. Hamilton invented the school long before he came to live nearby.

On Edwin Brett's death, in December 1895 at the age of sixty-seven, his armaments, described as 'one of the largest private collections of early arms and armour ever formed', was sold at Christie's for £30,000. Brett's publishing company went to his two eldest sons, Edwin and Edgar, but folded in 1909.

Charles Hamilton (Frank Richards) (1876–1961)

Billy Bunter, Charles Hamilton's most famous creation.

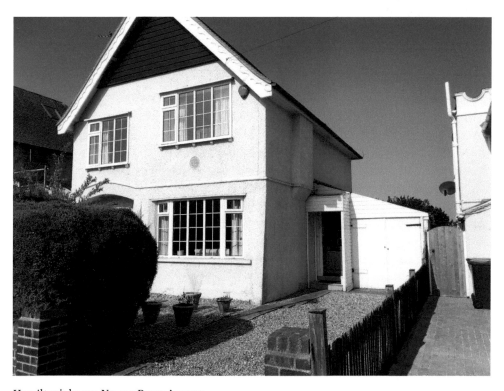

Hamilton's home, No. 131 Percy Avenue.

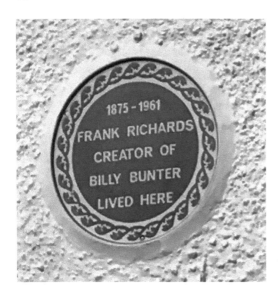

The plaque marking the residence of
Hamilton's alter-ego, Frank Richards.

On Christmas Eve 1961 a Thanet journalist called Bill Evans got a phone call from Edith
Hood, housekeeper to Charles Hamilton, to say that her employer had just died. 'Do you
think anyone would be interested?' she asked.

Charles Hamilton was an almost completely anonymous figure: a little man in a
skullcap and dressing gown, pipe in mouth, occasionally seen pottering around his
garden at Rose Lawn, No. 131 Percy Avenue, Kingsgate. Even his neighbours barely knew
him, despite his having lived in the house since 1926. His next-door neighbour said of
him: 'He was a very quiet man ...' but there was one clue to what he did with his time:
"whenever I was in the garden all I could hear was the sound of his typewriter".'

That typewriter, an ancient Remington with a purple ribbon, churned out a remarkable
100,000 words a week, 7.2 million in his lifetime, equivalent to over 1,000 novels. This
anonymous little man was the most prolific author ever. Under the pen name Frank
Richards, he wrote stories about Greyfriars' School and Billy Bunter and, under at least
twenty-seven further aliases, a whole range of other accounts of public-school life, and
boys' and girls' adventure stories.

It was as if Hamilton lived only through his writing, to such an extent that when he
wrote his autobiography, it was titled *The Autobiography of Frank Richards* ('the most
unrevealing autobiography of all time' according to the critic Benny Green).

From the time he came to Kingsgate, Hamilton rarely went out, apart from an early
morning walk the 400 yards to the beach at Botany Bay. Edith Hood arranged his
shopping, and everything else was done by post, including getting cash from the bank.
A cheque was posted and cash came back via registered mail.

Apart from his housekeeper, who lived with him for thirty years, Hamilton was close to
just three people: his sister Una (known as Dolly) and her daughter Una Hamilton Wright.
Dolly's husband Percy Harrison was Hamilton's best friend for over half a century, but the
family relied heavily on Hamilton for financial and emotional support. He bought them a
house across the road, then called Mandeville, so they could come and stay.

Charles Hamilton hadn't always been a recluse. As a young man, before the First World War, he travelled widely and almost constantly across Europe and was engaged – briefly – to a woman called Agnes. Later he had a relationship with an American woman he referred to as 'Miss New York'. Neither relationship appeared to mean much to him or, by his account, the women. In his autobiography he wrote: 'It is often said that men and women cannot be pals: the eternal sex aspect is bound to crop up sooner or later. But it is not so.' Referring to himself in the third person, and using the pen name that was also an alter ego, he goes on: 'If there was a spot of romance in Miss NY – as undoubtedly there was – Frank never saw anything of it ... No inexpressive she ever fell in love with Frank, so far as he knows. Certainly Miss NY didn't.'

Hamilton's talent as a writer of popular fiction for boys, and his almost unbelievably prodigious output, meant that he had money, earning £3,000 a year in the 1920s. Yet it poured out as fast as it flowed in, owing to an addiction to gambling. Hamilton would pop over to the casinos at Monte Carlo where, says David Seabrook in *All the Devils Are There,* he would 'stop at the first table and carelessly toss a piece, the first that came to hand, on Number Seventeen ... his lucky number – perhaps because it was at seventeen that he had struck lucky with scribbling. And, strange to relate, Number Seventeen did come up, many times. And many times it didn't and he came back home across the Channel cleaned out.'

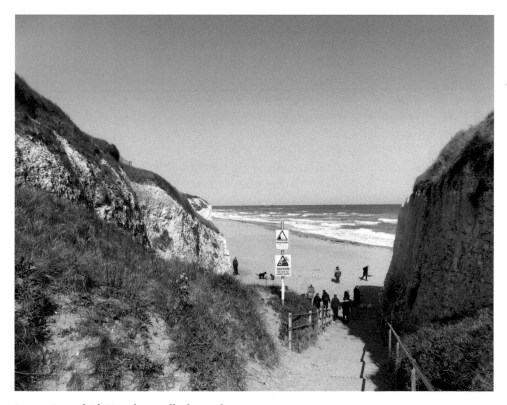

Botany Bay, which Hamilton walked to each morning.

With the optimism of a compulsive gambler, Hamilton obsessively developed systems, each of which he believed would 'break the bank at Monte Carlo'. They never did because, he told himself, the casinos were corrupt and fixed the odds.

Hamilton wrote: 'I used to visit, and re-visit, and re-re-visit the place, like a moth coming back to the candle'. Yet he never left England after 1926, when he arrived in Kingsgate.

He begins his autobiography at age seventeen, missing out his schooldays. It was one of Hamilton's greatest secrets that, despite writing extensively about boys at prestigious English public schools, it was a world he had no personal experience of. As Mary Cadogan notes in *Frank Richards: The Chap Behind the Chums,* his education was straightforward enough and 'it is surprising he should have taken pains to conceal it'. He went to several private day schools in his first home, Ealing and Chiswick, including Thorn House School, where he nevertheless developed an abiding love of Latin and Greek.

He was born, one of eight children, in a modest house at No. 15 Oak Street, Ealing. His father John was a journalist who died in 1884, when Charles was seven. His mother's brother, a successful local estate agent, saw that the family was housed, but moves were frequent, and he supported the family financially.

Perhaps it is telling that one of the characteristics of Charles's most famous creation, Billy Bunter, is that he exaggerates his parents' wealth, and elevates their modest suburban villa into Bunter Court, a country house with an imposing façade and vast acres.

Hamilton, finding he had a talent for storytelling, set about writing himself out of his humble origins. He instantly found success in the rapidly expanding market for boys' periodicals. A literary agent called Dowling Maitland bought his first story, and subsequent efforts, for five guineas (working men earned £2 a week at the time), but reduced the fee to £4 once he had met Hamilton and discovered how young he was.

From 1905 he specialised in school stories for *The Magnet*, *The Gem* and other periodicals, and put his success down to the fact that he 'never really stopped being a boy', and closely identified with the characters he created: 'every one of them is real'.

Times got very hard in 1940 when *Magnet* and *Gem* closed down, victims of the wartime paper shortage and tumbling circulations. Hamilton's income was reduced to almost nothing. With much of his capital gambled away, he got through the war years selling shares and works of art he had collected. In 1947 his luck changed again: a publisher asked him to write Billy Bunter hardbacks, and he turned out thirty-eight, writing until he died, successful once again, but still as much of an enigma.

DID YOU KNOW?
Richard Joy, a 7-foot-tall strongman known as The Kentish Samson, was buried in St Peter's churchyard in 1742. He performed feats before royalty, such as lifting 2,240 lbs. His stone carries this inscription: 'Herculean hero, fam'd for strength, at last lies here his breadth and length'. However, some contemporary accounts attribute Richard's feats to his brother, William, who was buried at sea in 1734.

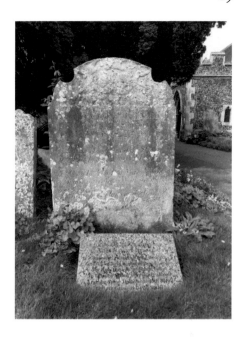

The grave of Richard Joy, Kentish Samson.

One person who got through the door at No. 131 Percy Avenue was A. D. Newman. In 1951 he answered an advertisement in the *East Kent Times* for a tutor prepared 'to read Latin verse with a backward pupil'. Mary Cadogan writes: 'He was amazed to find the "backward pupil" was a "venerable gentleman wearing a skull cap" … Mr Newman visited him regularly from 1951 until 1960 (by which time Hamilton was eight-five years old), and they read the whole of Horace, who was Charles's favourite author' among several others.

Oliver Postgate (1925–2008)

Many authors have a blue plaque to mark their former residence and Oliver Postgate is no exception. However, beneath the one dedicated to him at No. 4 Chandos Square in Broadstairs, there is a second, more individual tribute to the inventor of *The Clangers* and other much-loved characters.

It is a mosaic, commissioned by Postgate's partner Naomi Linnell, featuring Tiny Clanger and Major Clanger. They are looking up at the blue plaque and, although there is no caption, Naomi imagines Tiny Clanger to be saying 'Who's Oliver Postgate?' and Major Clanger replying 'You fool he made us!'

Ms Linnell explained that she often saw people looking at the plaque and not knowing who Postgate was: 'I wanted something that was visual in Broadstairs to remind people of Oliver and really to remind [them] of his work.'

From the 1950s to the 1980s, Postgate and his colleague Peter Firmin (who died in 2018) created a series of characters, including *Ivor the Engine, Noggin the Nog*, and *Bagpuss*, that captivated generations of children. Postgate narrated them in his distinctive baritone, and they were filmed in a converted barn at Firmin's farm at Blean near Canterbury. In a 1999 BBC poll *Bagpuss* was voted the most popular children's television programme of all time.

Oliver Postgate's home, No. 4 Chandos Square, Broadstairs.

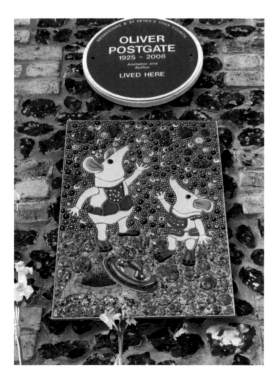

The Clangers mosaic and blue plaque.

Visitors to Postgate's basement flat, which he bought in the 1980s and referred to as his underworld, said it was rather like entering Emily's shop from *Bagpuss*. It was a cosy, cluttered cave stuffed with mementos such as the painted cardboard Viking helmet worn by Noggin the Nog and drawings of Ivor the Engine.

One visitor, Jonathan Benton-Hughes, recalled how Oliver 'breaks into all his characters all the time. One minute he's a narrator, then he's Professor Yaffle from *Bagpuss*. Then he's Bagpuss. I even detected a touch of Iron Chicken coming out over coffee. It seems like his characters are him – part of his personality.'

In 1982, Postgate's wife Prudence died from cancer, aged sixty. Prudence had three children when they met, and they had three boys together. Meeting Naomi in 1984 was a new beginning, and coincided with his television work going out of fashion and commissions drying up.

As Oliver explains in his autobiography *Seeing Things*: 'One bright morning in the autumn of 1984, the Keeper of the Printed Books of Canterbury Cathedral came to call on me' (at his then home, Red Lion Cottage on the Canterbury-to-Whitstable road). 'She was golden-haired and smiling ... and she had come to ask me to lend her my celebrated voice to record a tape-cassette guide for blind people to listen to as they walked through the Cathedral ... That was the start of a long and happy collaboration.'

The pair worked on further projects together, including an audio-visual show on Thomas Becket, the archbishop murdered in his cathedral in 1170.

Their 'working partnership had long since grown into a loving friendship' when Naomi contracted myalgic encephalitis, ME, a debilitating condition that caused exhaustion and affected her mobility. Naomi was married, to Geoffrey, but her husband appears to have been remarkably understanding of the bond that had grown between his wife and Oliver Postgate. Geoffrey, says Postgate, 'was a kind man but not as used to looking after people as I was. When Naomi was rotten he encouraged her to stay with me.'

Naomi bought a flat at No. 4 Chandos Square, and Oliver the adjacent one, replacing the staircase between the two that had been removed when the house was converted. He wrote of how 'Naomi's neat and comely flat is upstairs on the ground floor while my untidy badger's residence is below, though I have quarried out a tiny garden from some waste-ground at the back ... In the morning the sun comes singing into Naomi's front room. There we sit in the bow window and have breakfast, watching the seagulls.'

DID YOU KNOW?
Stevie Smith (1902–71), the poet best known for 'Not Waving But Drowning', spent three years in the Yarrow Convalescent Home after contracting tuberculosis peritonitis at the age of five. The home, in Ramsgate Road, was run by Westminster Hospital, and its full title was the Yarrow Home for Convalescent Children of the Better Classes. It closed in 1964, and the buildings now house East Kent College.

Postgate had always been an enthusiastic amateur inventor and, with Naomi's condition worsening, he created a series of tools to make her life easier, including: a wrench for opening jars and turning taps and door handles; a plastic hook to open ring-pulls on cans of fish; and, because gout in his knees made it increasingly difficult for him to push her along, 'a battery driven outboard motor to fix on to her ordinary folding wheelchair' with power steering.

Broadstairs was an idyllic spot for Oliver Postgate in his final years. He describes buying a bacon and egg-mayonnaise baguette from the corner delicatessen and then: 'I walk down to the cliff-top promenade and sit on one of the park-benches (placed there in memory of past loved ones), watch the boats bobbing in the harbour, feel the sun and the gentle breeze ... There, in the clear air, it seems possible that the world will be able to get by without me.' Meanwhile: 'Like a diminutive Boadicea, Naomi buzzes about the town and along the windy cliff-tops in her three-wheeled electric chariot.'

Oliver died on 8 December 2008, aged eighty-three. His youngest son, Daniel, inherited his father's company, and has since created a new series of *Clangers* on CBeebies.

Postgate and *Bagpuss*.

The view Postgate loved to gaze at.

6. Thomas Crampton: Unsung Hero

Thomas Crampton was made an Officer of the Legion d'Honneur by Napoleon III of France and awarded the Order of the Red Eagle by Frederick William IV of Prussia, yet, in Britain, one of the most accomplished inventors and engineers of the Victorian era has never received a single honour.

Here are three things for which Crampton (1816–88) ought to be famous, and celebrated, but isn't: in designing the Crampton steam locomotive, he was the father of the high-speed train; his invention of the electric telegraph meant that information could be transmitted instantly across continents; in developing an automatic tunnel boring machine, intended to cut a tunnel beneath the English Channel to France, he laid the foundation for modern tunnelling methods.

Throughout his life, Crampton developed an astounding succession of projects. He was granted twenty-one patents between 1842 and 1886, many for improvements to locomotive engines, but also for significant advances in brick and cement manufacture, the design of kilns and furnaces, the manufacture of iron and steel, cast-iron military forts, and improvements to everything from roads to matchboxes.

Thomas Crampton.

Crampton's water tower
and 'beehive' reservoir.

Crampton in Broadstairs

However, if Thomas Crampton's country has failed to honour this most talented of sons, it's a different matter in his home town of Broadstairs, where the improvements he made and his contribution to the welfare of the town are remembered and appreciated.

Thomas was the son of John and Mary Crampton of Prospect House, on the corner of what are now Eldon Place and Dickens Walk. His parents – John was listed in town directories variously as a plumber, architect and landlord – ran the Vapour and Medicated Baths next door to Prospect House, where Chiappini's café now stands. Charles Dickens was among their customers.

Thomas married Louisa Hall, a singer and friend of Jenny Lind, and they had eight children – six boys and two girls. Sarah, the eldest girl, died at the age of four, and Crampton had a stained-glass window placed in St Peter's Church in her memory. Crampton's other daughter, Louisa, is remembered in the wrought-iron footbridge he donated, laid across Goodson Steps, and known as the Louisa Gap bridge. His first wife died in 1875 and he married Elizabeth Werge in 1881.

Crampton's Louisa Bridge.

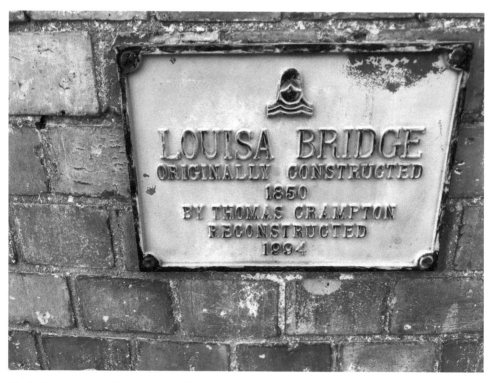

The bridge was named in memory of Crampton's daughter.

Crampton's two pioneering projects in Broadstairs were the provision of gas and mains water. In 1851 he built, and largely funded, the Broadstairs Gasworks, but the development was not without controversy. Charles Dickens records the fight it caused in *Our English Watering Place*:

Dissension ... has arisen on the novel question of Gas. Our watering-place has been convulsed by the agitation, Gas or No Gas. It was never reasoned why No Gas, but there was a great No Gas party. Broadsides were printed and stuck about – a startling circumstance in our watering-place. The No Gas party rested content with chalking 'No Gas!' and 'Down with Gas!' and other such angry war-whoops, on the few back gates and scraps of wall which the limits of our watering-place afford; but the Gas party printed and posted bills, wherein they took the high ground of proclaiming against the No Gas party, that it was said Let there be light and there was light; and that not to have light (that is gas-light) in our watering-place, was to contravene the great decree. Whether by these thunderbolts or not, the No Gas party were defeated; and in this present season we have had our handful of shops illuminated for the first time. Such of the No Gas party, however, as have got shops, remain in opposition and burn tallow – exhibiting in their windows the very picture of the sulkiness that punishes itself, and a new illustration of the old adage about cutting off your nose to be revenged on your face, in cutting off their gas to be revenged on their business.

Prospect House.

Chiappini's, formerly
the Vapour and
Medicated Baths.

In 1859, concerned that most of the town's water supply was drawn from private wells serving individual houses, or groups of houses, Crampton formed the Broadstairs Water Company, sinking a well on a site across the High Street from the railway station, with a gas-operated engine bringing water up into an 80-foot water tower and adjacent brick-domed reservoir holding 73,000 gallons. From here water was piped around the town. It was taken over by the Broadstairs Urban District Council in 1901 when demand outstripped its capacity and it was discovered saltwater was tainting the supply. New wells were dug further inland at Rumsfield Road.

Four years previously, Crampton had built the Berlin waterworks, for which Frederick William IV of Prussia appointed him to the Order of the Red Eagle. No such awards were offered in England, but a small museum to this local hero now stands at the base of the Crampton Tower.

Crampton's Impact on the Wider World

Thomas Crampton began his engineering career in 1831, a few years later becoming an assistant to Marc Brunel, father of Isambard Kingdom Brunel, on the design of locomotives for the Great Western Railway. He later worked with Daniel Gooch, the GWR's superintendent of locomotive engines, in his attempts to convince the Board of Trade and key members of Parliament of the superiority of locomotives built to run on the broad gauge of 7 feet then favoured by the GWR over those used on the standard 4 feet 8.5 inch gauge preferred by other companies.

It was a battle of competing technologies that the GWR was destined to lose. Crampton, perhaps sensing this outcome, hedged his bets. He secretly worked – without telling his employers – on designing a standard gauge locomotive that would be as good as a broad gauge one.

He realised that broad gauge locomotives were superior to standard gauge for a number of reasons: there was room for larger boilers, a bigger fire box and heating area. Also, larger driving wheels meant higher speeds while working the pistons less hard. In 1843 Crampton patented his own rival design, with technical improvements and looks, which laid the foundation for future locomotive design.

DID YOU KNOW?
Thomas Crampton's gasworks stood in what is now the Albion Street car park. Coal burned to produce gas left a byproduct, tar and liquor, which had to be disposed of. Bob Simmonds, in *Broadstairs Harbour,* says 'this was run down a pipe under Harbour Street and then discharged to special tank barges via the flanged pipe still seen protruding from the pier.'

The pipe through which the gasworks waste was pumped into barges.

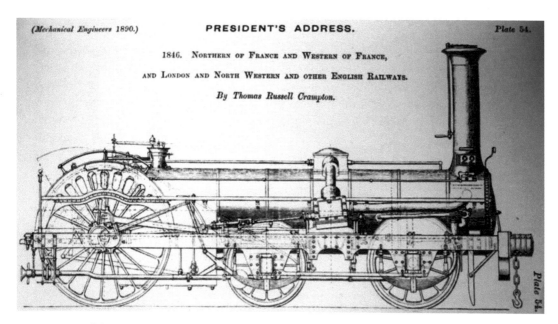

Crampton's locomotive design.

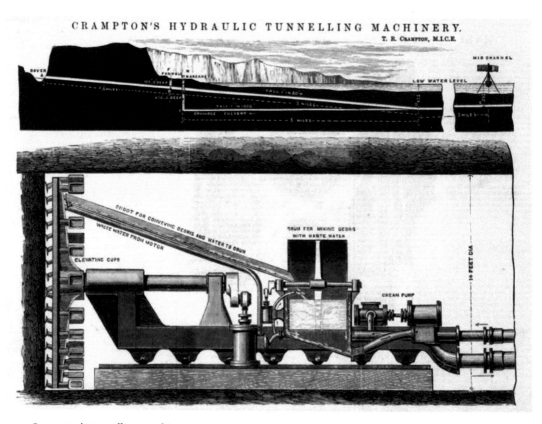

Crampton's tunnelling machine.

While Crampton's design was not hugely popular in Great Britain, it was massively successful in France and Germany. His proved to be the perfect machine for tackling the long distances, on straight tracks, at consistently high speeds, between major continental cities. Crampton's locomotive – refined by the Parisian engineering company Cail – dominated continental railways for forty years and was exported to Russia, Egypt and many other countries. He became so famous, and his name so well known, that passengers talked of 'taking a Crampton' ('je vais prendre le Crampton') as we might talk of using a Hoover or Dyson.

Napoleon III was such an enthusiast for Cramptons that, when Queen Victoria made an official visit to France, he instructed that one should pull the royal train from Calais to Paris, and later awarded Crampton the Legion d'Honneur.

In 1851, Thomas Crampton laid the first international submarine cable across the Strait of Dover to Cap Gris Nez, enabling telegraph transmissions between Paris and London. Crampton not only designed the cable, he also funded the £10,000 cost of the project.

Several previous attempts had ended in failure but, as the Institute of Civil Engineers recorded in their obituary of their distinguished member:

[He] had the satisfaction, on 25 September, 1851, of announcing to the men of science assembled round the Queen at the ceremony of the closing of the Great Exhibition, that he had achieved a task which engineers and capitalists had combined to treat as impossible.

The vast importance of the work then accomplished can hardly be over-estimated. It was the first step in submarine telegraphy, and from it have sprung the prodigious developments of that system which now connects all parts of the civilised globe in a network of electrical wires. Mr. Crampton may, therefore, fairly be considered as the father of submarine telegraphy.

From Dover to London, the cable ran alongside the South Eastern Railway, which Crampton had a substantial interest in. He was wholly or partly responsible for building Kent railway lines, including those between Strood and Dover, Sevenoaks and Swanley, and Herne Bay and Faversham. He also built lines in Greece and Bulgaria, and owned a brickworks and limekilns at Sevenoaks and Otford.

Crampton's other great contribution to engineering was his work on automatic tunnel boring equipment. He was by no means the only engineer working on a way of cutting tunnels that was more efficient than the use of drilling and blasting but, as the Crampton Locomotive Trust recounts,

He produced a revolutionary automatic tunnel boring system in which debris was conveyed away in pipes by hydraulic motors, mixed with waste water, thus eliminating all locomotives, wagons and lifting machinery. The system was demonstrated in the experimental works of the Channel Tunnel Company, and described by Crampton in a lecture given [to the Institution of Mechanical Engineers] in Leeds in 1882.

Successful starts were made on digging a Channel Tunnel at both the English and French ends, but the project was abandoned in 1883 after fears were raised in Britain that the route would make the country vulnerable to invasion.

DID YOU KNOW?
John Mockett's *Journal* of 1836 records a tragic consequence of an ancient Christmas custom, in which men and boys dressed up to amuse people. Mockett says: 'It unfortunately happened, this year, that a man dressed in a bear skin, met a young woman named Crow, the wife of John Crow, Broadstairs, and alarmed her so much that she was obliged to go to a friend's house to recover herself; and in returning home, she met the same man again, which so dreadfully alarmed her that she died the next day. A coroner's inquest was held on the occasion; and hand-bills circulated to prohibit such practices in future.'

Honoured in Broadstairs: Crampton has a pub named after him.

Nevertheless, as the Iron and Steel Institute explained in their obituary of Crampton, his method was ingenious, and cheap. It directed the water encountered while drilling to the cutting blades, 'mixing with the debris as cut, and generally preventing the accumulation of debris on the machine'. At the Channel Tunnel, chalk was cut through at the rate of 5 yards per hour, 'the power used being 1.2 horse-power per hour. At the Mersey Tunnel, sandstone was cut through at 1.5 yards per hour, at four horse-power per cubic yard per hour. The cost of one horse-power per hour is less than one penny.'

Thomas Crampton's invention was the forerunner to modern drilling techniques used wherever tunnels are dug.

He died at his London home, No. 19 Ashley Place, Victoria Street, Westminster, and is buried in Kensal Green Cemetery.

7. Famous Visitors and Residents

Oscar and Willie Wilde

Broadstairs crops up at several key moments in the life of Oscar Wilde. He visited several times, staying at the Royal Albion Hotel, but it was concerns over his dissolute older brother Willie that first brought the town into his story in a more material way.

Willie was a talented and successful journalist and poet, writing for the *Daily Telegraph* and *Vanity Fair*, but he wasn't a genius like Oscar, whose achievements eclipsed his own, and that rankled. Willie was an alcoholic and constantly in debt.

Things might have changed in 1891 when, at the age of thirty-nine, Willie married Miriam Leslie, a fabulously wealthy American widow and heir to the publishing empire of her late husband Frank. Miriam had been attracted by Willie's wit and charm, but when they married and he moved to New York, she saw his dark side. Within a year she had initiated divorce proceedings on the grounds of his drunkenness and adultery.

Willie returned to England in 1892 and met another woman, Sophie – known as Lily – Lees, and they lived together in Broadstairs, where his dissolute appearance and debt-ridden existence attracted a good deal of comment. In 1893 the essayist Max Beerbohm wrote in a letter to a mutual friend:

OSCAR WILDE

Oscar Wilde. (The Wellcome Collection)

Wilde stayed at the Royal Albion Hotel while visiting his dissolute brother Willie.

> I saw a good deal of Willie at Broadstairs … *Quel monstre!* Dark, oily, suspect yet awfully
> like Oscar: he has Oscar's coy carnal smile and fatuous giggle and not a little of Oscar's
> *espirit*. But he is awful – a veritable tragedy of family likeness.

Oscar and Willie's mother, Lady Jane Wilde, wrote to Oscar to express her concerns
about Willie: 'He seems bent on Lily Lees – and who can say how all will end.' It ended
in marriage, with the dissolute pair living off, and moving in with, Lady Wilde. Again
she wrote to Oscar: 'Miss Lees has but £50 a year and this just dresses her. She can give
nothing to the house and Willie is always in a state of utter poverty. So all is left upon me.'

Oscar confronted his brother, opening a rift that was still unhealed when alcoholism
killed Willie, at the age of forty-six, in 1899.

However, another more personal crisis was about to engulf Oscar, and Broadstairs
would again play a small but significant part in it.

For some years Wilde had been using male prostitutes. His homosexuality was known
about in society circles, but his relative discretion meant he was not exposed. However,
when he began an affair with the far less discreet Lord Alfred Douglas, known as Bosie,
his fate was sealed. Bosie's father, the Marquess of Queensbury, demanded that Wilde
stop seeing his son.

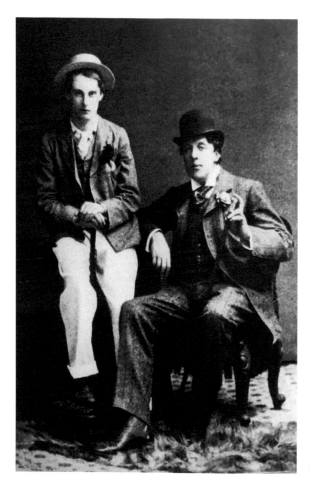

Wilde with Lord Alfred Douglas.
(Uriel1022 under Creative
Commons 2.0)

When Oscar ignored him, Queensbury set a trap, leaving a card at Wilde's club addressed 'To Oscar Wilde posing as a sodomite'. Note that he did not say Oscar *was* a sodomite, only that he posed as one. Such a claim would be easier to defend in any court action but, Queensbury calculated, just as damaging.

Queensbury's gamble was that Wilde would sue for libel, enabling him to present evidence of Oscar's homosexuality in court. It worked. That year, 1895, Oscar's *The Importance of Being Earnest* was a sensation and he was probably the most famous man in England, but the court case was to ruin him.

To defend his allegations in court, Queensbury had to demonstrate justification that his claims were true. To gather the necessary evidence, Queensbury had private investigators from the Pinkerton's agency gather statements from men Wilde had slept with and who had sometimes blackmailed him.

DID YOU KNOW?
What is now the Palace Cinema in Harbour Street was once a museum housing the armoury collection of Sir Guy Laking, and named York Gate Hall. Laking was a foremost expert in arms and armour and, from 1902, Keeper of the King's Armour. Adjacent York Gate House had been bought as a country bolthole by Guy's father, Sir Francis Laking, surgeon-apothecary to Queen Victoria, and later physician to Edward VII and George V. From 1910, York House accommodated Prince Henry, the ten-year-old son of George V, while a day pupil at St Peter's Court School.

In Broadstairs they tracked down two professional blackmailers, Allen and Clibborn (or Cliburn or Clibborne, all three spellings of his name appear in court documents), who had gone into hiding in the town, and managed to persuade them to sign statements that would prove damning in court.

The Palace Cinema, former armoury museum, and York Gate House.

The pair had obtained a letter Wilde had written to Bosie in which he said 'it is a marvel that those rose-red lips of yours should have been made no less for music of song than for madness of kisses'.

Allen and Clibborn testified in court that, first, they had tried to blackmail Oscar, going to his house in Tite Street, Chelsea, to tell him they had been offered £60 for the letter. He dismissed them with half a sovereign each, and told Clibborn: 'I am afraid you are leading a wonderfully wicked life,' to which Clibborn replied: 'There's good and bad in every one of us.' Stricken by guilt, the two blackmailers returned the letter without further payment.

Unfortunately for Wilde, Queensbury obtained a copy of the letter. It, and testimony from Atkins and Clibborn, meant Wilde lost his case. Two criminal trials followed, in which Wilde was accused of gross indecency. He was found guilty and sentenced to two years hard labour in Reading Gaol.

A further Broadstairs connection comes in the figure of Lionel Pigot Johnson, a poet, essayist and critic who was born in the town. Johnson was Lord Alfred Douglas's cousin and a friend of Oscar Wilde and, one afternoon in 1891, introduced them to each other by bringing Bosie to tea at Wilde's house. When the scandal of their relationship broke, Johnson, an alcoholic who repressed his homosexuality, bitterly regretted having initiated their transgressive love affair. He condemned Wilde, directing a sonnet at him called 'The Destroyer of the Soul', believed to refer to the soul of Bosie.

In a final Thanet connection, the Marquis of Queensbury was defended against Oscar's libel action by Edward Carson, who later lived in Cleve Court, a Georgian manor house on the road between Minster and Acol.

D. H. Lawrence

D. H. Lawrence (1885–1930) stayed at Riley House, No. 28 Percy Avenue, Kingsgate, with his married lover Frieda Weekley in 1913 during their elopement. The couple had met the previous year and escaped to Germany together. This had been a traumatic time, with Lawrence arrested on suspicion of spying, but also a creative one, with the completion of *Sons and Lovers,* his first major novel.

Lawrence said No. 28 Percy Avenue was 'a most jolly little flat. The big bedroom has a balcony that looks across the fields to the sea. Then the house has a tent [a changing tent at the beach] and the way down to the sea is just near, so one can bathe'. He described the little bay where 'great waves come and pitch one high up, so I feel like Horace, about to smite my cranium on the sky'. Yet the couple, who insisted on bathing naked, felt no affinity with other holidaymakers. Lawrence wrote: 'I feel horribly out of place among these villas.'

D. H. Lawrence.

No. 28 Percy Avenue, Lawrence's
holiday home.

Walter Sickert

The artist Walter Sickert (1860–1942) moved to the St Peter's area of Broadstairs in 1934 when he became broke and had to leave London. As Craig Brown notes in *Hello Goodbye Hello: A Circle of 101 Remarkable Meetings*:

> Famously spendthrift – he can never resist taxis, telegrams, clothes, leaseholds and bric-a-brac – Sickert has been on the verge of bankruptcy, owing well over £2,000 to landlords, art dealers, tradesmen and, not least, the Inland Revenue ... A group of his friends rode to his rescue by launching an appeal and raised £2,005; they then persuaded him to move from London to Kent.

Sickert found happiness in St Peter's, and his self-portrait, painted on the front step of the house he rented, Hopeville in Church Road, is entitled *Home Sweet Home*. He renamed the house, three doors down from St Peter's Church, Hauteville during his four-year stay.

Sickert was in his seventies and married to his third wife Thérèse but, says Brown, he was still 'frisky and freewheeling', and 'flung himself into an affair with the twenty-seven-year-old Peggy Ashcroft, fresh from her success in *Romeo and Juliet* at the Old Vic'.

Hopeville, Sickert's home in St Peter's.

He lectured at Thanet School of Art Hawley Square Margate, now Margate Adult Education Centre, and painted a series of portraits of the famous. Sickert converted a Georgian stable block at the house into a studio, and had 'a hutch-like construction' where he hung his paintings to dry.

Sickert was a bohemian figure, and was once removed from Broadstairs seafront by police, who mistook him for a tramp. Few people in the village knew who he was, but his distinctive dress – flowing opera cloak, wide-brimmed hat and collarless shirt – got him noticed, as did his excessive friendliness. He was known to invite total strangers home for tea and bananas.

His house was adjacent to the playground of St Peter's Primary School and, valuing the opinions of children, he sometimes placed his newly completed canvases where they could see them so that he could hear their comments.

Edward Heath

Sir Edward Heath. (Allan Warren under Creative Commons 2.0)

Heath's plaque at Broadstairs Sailing Club.

As the leader of the Conservative Party and Prime Minister from 1970–74, Sir Edward Heath is the most prominent pubic figure to come out of Broadstairs. The bare facts of his connections with – and great affection for – the town are familiar to many, but there is a key personal story that is much less well known: the broken love affair that, it seems, put him off women for good.

Ted (1916–2005) came from a very modest background: father William was a builder and mother Edith had been a chamber maid. His first home was a flat at No. 1 Holmwood Villas in Albion Road. The family moved to King Edward Avenue when William's business thrived.

Heath attended St Peter's Primary School before winning a scholarship to Chatham House Grammar School in Ramsgate. From there he won an organ scholarship to Balliol College, Oxford, where he said during interview that his ambition was to be a professional politician. In fact, he once told an interviewer he had decided to be Prime Minister while still at Chatham House but added 'I didn't tell the other boys as they might have been jealous.'

An accident led to a chance encounter that was to be one of the most significant of his life. Ted was knocked off his bicycle by a car and taken to the surgery of Dr Raven. Here he bumped into the doctor's daughter, Kay. A friendship began.

Ted was always very reluctant to talk about the relationship. In his autobiography, *The Course of My Life*, the most he will say is: 'She was a delightful girl and we shared many interests, including tennis and swimming as well as music.'

DID YOU KNOW?
Holmes Park, on Knights Avenue, is named after George Augustus Holmes (1861–1943), an organist, composer and founder of the London College of Music. Holmes owned a number of properties in the area, including his weekend retreat Breeze Holm, and bequeathed a meadow and some building plots to Broadstairs Urban District Council in his will. He asked that the area be preserved 'as a rest and pleasure garden and recreation ground for the use of residents and visitors'.

The pair wrote to one another throughout the war while he served in the Royal Artillery Regiment and she was a WAAF. Sir Edward's account continues: 'After I returned home in 1946, we still remained separate because we were working in different parts of the country.'

The relationship continued into the 1950s, but then ended. Why? When the broadcaster Michael Cockerell asked that question this exchange resulted:

'She decided she would marry someone else, but I don't discuss these things,' said Heath.

'Did you get over it?'

'Yes.'

'It was said you kept her photograph by your bed.'

'Yes.'

'Did you?'

'Yes.' – and he looked away, as if close to tears.

In fact, Kay's letters to Ted, uncovered by Philip Ziegler in his biography *Edward Heath,* make it clear she would have married her 'Darling Teddy' if given the slightest encouragement. Having waited so many years for Ted to propose, Kay had simply given up hope.

In 1950, the year Sir Edward became an MP, Kay met Flight Lieutenant Richard Buckwell while on a caravanning holiday in Scotland. When she wrote to tell Heath she had decided to marry, she said: 'You know I'm rather a loving kind of girl and must have been a horrid bore for you.'

Heath was angry and made what he saw as her betrayal a reason for never looking at another woman. He told Ziegler: 'One day she suddenly let me know that she was marrying someone else. I was saddened by this. I had been under such pressure, re-adapting myself to civilian life and earning a living, that maybe I had taken too much for granted ... I subsequently learnt that Kay had a happy life with her children, but we never met again.'

When Buckwell left the RAF in 1960, the couple farmed in Scotland. Kay died of cancer in 1978, and Sir Edward wrote a letter of condolence to her husband.

Even Ted's closest female friend, Sara Morrison, vice chairman of the Conservative Party in the 1970s, could get no more out of Ted on the topic of Kay. She believed Heath was simply not interested in sex. 'I did once ask him if he ever slept with her [Kay] and he grinned at me and said: "That is an indelicate question." When I persisted he just said "I'm not going to answer that", but I'm pretty sure he didn't.'

Sir Edward returned to Broadstairs regularly, even at the height of his political career, to visit his parents and enjoy his hobbies of sailing and music. A blue plaque in Harbour Street records his membership of Broadstairs Sailing Club.

Bibliography

In writing this book I have read or consulted the following books, publications and websites:

Ackroyd, Peter, *Wilkie Collins* (London: Chatto and Windus, 2012)

Addison, Adrian, *Mail Men: The Unauthorised Story of the Daily Mail* (London: Atlantic, 2017)

Anonymous, *Charles Dickens and his Bleak House* (Broadstairs: Bleak House, 1963)

Banham, Christopher Mark, *Boys of England and Edwin J. Brett, 1866–99* (Leeds: University of Leeds, 2006)

Benton-Hughes, Jonathan, *Excavating the Music of The Clangers* (http://www.offthetelly.co.uk)

Bird, James E., *The Story of Broadstairs and St Peter's* (East Kent: Lanes, 1975)

Bradley, A. G., *England's Outpost* (London: Robert Scott, 1919)

Brown, Craig, *Hello Goodbye Hello: A Circle of 101 Remarkable Meetings* (London: Simon & Schuster, 2013)

Buchan, John, *Memory Hold-The-Door* (London: Hodder & Stoughton, 1940)

Buchan, William, *John Buchan: A Memoir* (London: Buchan & Enright, 1982)

Charlton, Martin, *Buchan, Broadstairs and the 39 Steps* (Kent: Bygone Kent, 2019)

Cockerell, Michael, *Ted Heath and Me* (London: The Guardian, 2005)

Crampton Locomotive Trust (http://www.cramptonlocomotivetrust.org.uk)

Crampton Tower Museum, Broadstairs (http://www.cramptontower.co.uk/in-broadstairs.php)

Grace's Guide to British Industrial History (https://www.gracesguide.co.uk/Thomas_Russell_Crampton)

Hasted, Edward, *The History and Topographical Survey of the County of Kent* (https://www.british-history.ac.uk)

Heath, Edward, *The Course of My Life* (London: Hodder & Stoughton, 1998)

Hughes W. R., *A Week's Tramp in Dickens-Land* (London: Chapman and Hall, 1891)

Hunt, Michael, *In Search of the Broadstairs Shipbuilding Industry* (Ramsgate: Michael's Bookshop, 2014)

Hyde, Montgomery H., *The Trials of Oscar Wilde* (New York: Dover, 1962)

Ilchester, Earl of, *Henry Fox, First Lord Holland* (London: John Murray, 1920)

Jones, David, *Oliver Postgate (Daily Mail*, 10 Dec 2008)

Lapthorne, William H., *Smugglers' Broadstairs* (Ramsgate: Thanet Antiquarian Bookclub, 1970)

Lewis, Richard, *Artistic Thanet* (Broadstairs: Richard Lewis Books, 2017)

Lewis, Richard, *Discovering More Artistic Thanet* (Broadstairs: Richard Lewis Books, 2016)

Lewis, Samuel, *A Topographical Dictionary of England* (London: S. Lewis, 1848)

Mockett, John, *Mockett's Journal* (Canterbury: Kentish Observer, 1836)

Seabrook, David, *All The Devils Are Here* (Cambridge: Granta, 2002)

Simmonds, Bob, *Broadstairs Harbour* (Ramsgate: Michael's Bookshop, 2006)

St Mary's Chapel, (Historic England https://historicengland.org.uk/listing/the-list/ list-entry/1239199)

Turner, Arthur C., *Mr Buchan, Writer* (London: SCM Press, 1949)

Unattributed, *Secrets of Kingsgate Castle* (https://kingsgatecastle.wordpress.com/)

Unattributed, *Thanet's Raid History* (Thanet: Thanet Advertiser, 1919)

Ziegler, Philip, *Edward Heath* (London: Harper Press, 2011)

Acknowledgements

The author and publishers would like to thank the following people/organisations for permission to use copyright material in this book: The Wellcome Collection; Philip V Allingham, Victorian Web; British Libary; Acabashi; Gerry Bye, Anthony Roll; Le Deluge; Uriel1022; and Allan Warren.

Every attempt has been made to seek permission for copyright material used in this book. However, if we have inadvertently used copyright material without permission/ acknowledgement we apologise and we will make the necessary correction at the first opportunity.